CW00347128

Contents

1. View from The Backs

Cambridge conjures up a kaleidoscope of images: colleges; porters; punting; the view of King's College Chapel from The Backs; *Carols from King's*, which commands a regular slot on Christmas Eve television; the Boat Race. Cambridge is, of course, a university, one half of that composite entity Oxford-and-Cambridge or Oxbridge. And not just a university, but one of the world's leading universities. No matter which league table you read, it is invariably in the top ten, often the top three, ahead of larger and richer household names. This is a measure not of age or tradition, but of current performance in a cut-throat academic world.

The visitor can easily forget that Cambridge is not just a university; it is a town of 125,000 people, elevated to the status of a city in 1951. Historically, it controlled an important river crossing. Civic life had gone on here for half a millennium before a small

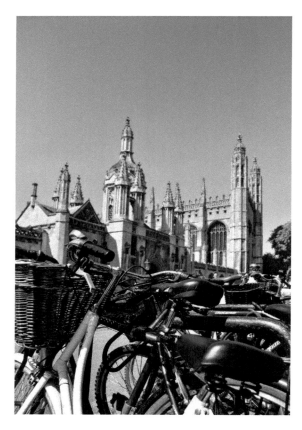

King's College Chapel and bicycles – two icons of Cambridge.

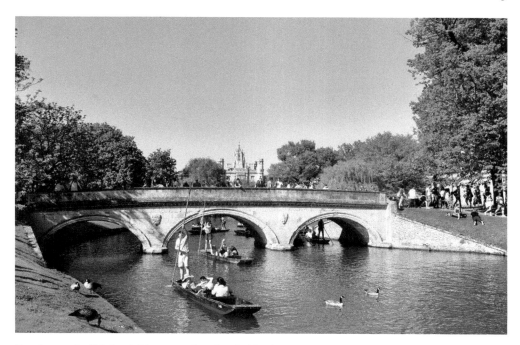

Punting under Trinity Bridge – another Cambridge icon.

band of temporarily homeless scholars decided to settle, and it continued alongside the academic newcomers. Two communities sharing a single space is never comfortable, and the centuries of coexistence were inevitably marked by tensions and conflicts. The university was more skilled than the civic authority at turning these to its advantage, gradually becoming the dominant power and thereby stoking tensions. Today, historical conflicts are resolved.

An earlier Cambridge lived out its life before these two squabbling siblings appeared – Roman Cambridge. Like its medieval successor, commercial life revolved around the bridge. A settlement, later walled, stood on the higher land overlooking the river, while a suburb grew up on the opposite bank. Nothing of this thriving settlement remains to be seen above ground – archaeology is still uncovering its bones – though the line of the main road along Bridge Street and St Andrew's Street is its legacy.

Tradition and history exert a fascination which draws around 5.5 million visitors to Cambridge annually. What the visitor expects, the visitor sees: a stage set, timeless façades, history in mellow brick and stone, lawns running down to the river, privilege and seclusion, relics from a more gracious age, tradition at every turn. The university is a mysterious world that the outsider can never enter. Glimpsed through a half-open gate, its hidden life flows back and forth, animated or abstracted, past 'PRIVATE' signs and bowler-hatted porters, with all the confidence of membership. In his autobiographical poem 'The Prelude', William Wordsworth reflected on his first weeks as an undergraduate at St John's College in 1787. As a simple northern villager, he says, he was impressed by the spectacle and overawed at the thought of the great minds of the past with whom he

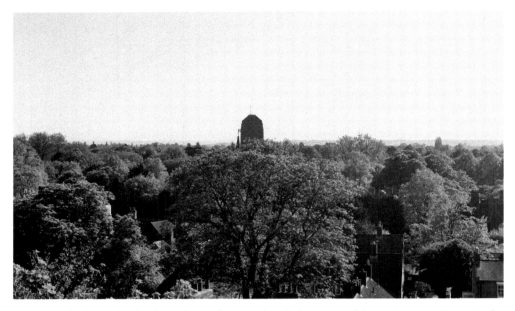

View over leafy Cambridge from the castle mound with the tower of the University Library in the distance.

shared these almost sacred spaces. Many new undergraduates and first-time visitors will echo his sentiment, 'I was the Dreamer, they the Dream'. All this is a carefully maintained illusion. Under its cover, the university works hard, a modern, state-of-the-art teaching and research institution.

Water has helped shape Cambridge's character. A low-lying, fen-edge, riverside town, the River Cam made it and still enlivens it. To quote Rupert Brooke's well-known poem, 'The Old Vicarage, Grantchester', generations of students remember:

> ...the thrilling-sweet and rotten
> Unforgettable, unforgotten
> River-smell...

To the north lies the wet fen, which was more extensive before the great drainage schemes of the seventeenth century. Water meadows, now mostly reclaimed as parks and lawns, still bring the countryside close to its heart. The town spans the Cam at the point at which its damp valley narrows to just a few tens of meters. On the west bank, a spur of chalk projects towards the river, while on the east bank a well-drained spread of gravel reaches a height of 30 feet around Peas Hill. This was the lowest crossing point on the river and it was this that gave the location its enduring military and commercial importance. Upstream the natural channel divided into several smaller meandering streams, but by the end of the seventeenth century the riverside colleges appear to have canalised the river as they reclaimed the valley bottom for gardens. It was still a working river, so to keep the towpath off their contemplative banks a gravel ridge was laid in

midstream. Old prints show horses up to their withers in the river, pulling laden barges as far as the millpond. The experienced punter still follows that gravel bed. However, even a tamed river like the Cam cannot be taken for granted. No doubt earlier periods accepted flooding as an inevitable part of riverside life, and college cellars are still occasionally flooded despite active river management.

Architecture and building materials add to a sense of place. Cambridge is a town of narrow streets and pedestrian passageways leading directly from our medieval and Saxon forefathers; no one felt the need to replan and rebuild. Many modest buildings are still timber-framed; an impressive sixteenth- or seventeenth-century group wraps around the corner of Magdalene Street and Northampton Street. As façades tend to be plastered, little timber work can be seen: the best is Nos 15–16 Bridge Street with its projecting upper stories; No. 14 Trinity Street displays fine, though restored, timber work and plasterwork; while the president's lodge in Queens' College is a rare collegiate example. The local building stone is clunch, a form of chalk that does not weather well. Importing better quality limestone was expensive, so many of the fifteenth-century college builders were early adopters of brick, creating a warm, mellow atmosphere. At Queens', Jesus and St John's, for example, brick forms a weatherproof veneer over cheaper clunch. Stone was bought in, particularly for churches and later for the grand architectural statements of the eighteenth century. Different sources were used at different times, creating a patchwork of textures.

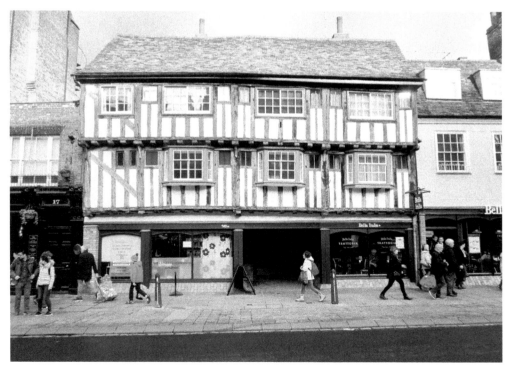

Nos 15–16 Bridge Street is perhaps the most striking example of a half-timbered building. It was probably originally a shop with accommodation above. (© Andrew Sargent)

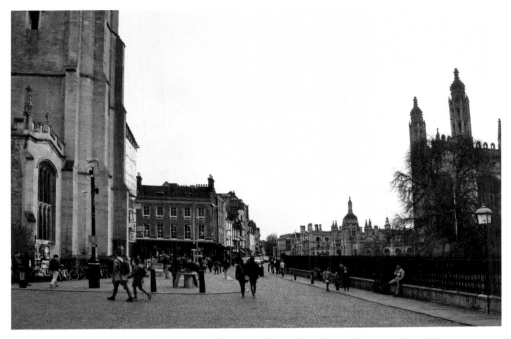

King's Parade, with St Mary the Great on the left and King's College Chapel on the right.

A lack of natural resources meant that little industry developed in the local region. Historically, this restrained growth and helped to preserve the feel of a market town. Industry, when it did arrive, tended to be clean, small-scale and not intrusive.

Two forms of transport are integral to the Cambridge dream: the bicycle and the punt. Punts, those adapted fenland watercraft, offer the sightseer an unusual perspective. Further downstream, rowers can often be seen on the water, perhaps practising for the Bumps. These are rowed twice a year from Fen Ditton to Chesterton, the Lents (in February or March) and the Mays (in June). As the river is too narrow for eights to race side by side, they have a staggered start with the aim of catching or 'bumping' the boat ahead, hence 'Bumps'.

There is much to see in Cambridge. Rather than taking the reader building by building on an 'architecture crawl', this book sets out to trace the history of both town and university, and to point to the witness of the surviving fragments. On the way, it tries to sketch the outlines of the origin and development of those two almost mythic protagonists, town and gown, so the reader is equipped to understand rather than simply to appreciate or notice.

An important note: colleges are not museums, but places in which communities of students and academics live and work. As a result, they are often closed to visitors in term time and particularly during the exam period. Most are open at advertised times, especially during the university vacations, though they may charge an entrance fee. Please respect the privacy of those who live there.

Posters and bicycles crowd the railings of the former All Saints' Churchyard in St John's Street, now often used for a craft market.

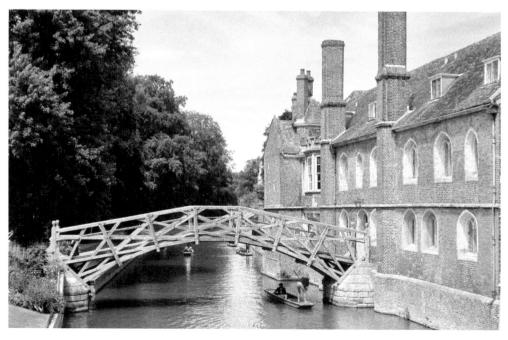

The Mathematical Bridge at Queens' College, originally designed by William Etheridge in 1749, has been rebuilt several times. (© Andrew Sargent)

2. The Roman Centuries

This story begins with a chapter on the Romans. It is not surprising that the conquering Romans found this fertile landscape well settled. Julius Caesar, writing almost a century earlier, had noted that southern Britain was occupied by a numerous population living in closely spaced farmsteads. Archaeology has confirmed a similar pattern for the Cambridge region, with settlements and field systems identified almost everywhere that large-scale development takes place: from West Cambridge to Addenbrookes, Trumpington to Histon Road, and many places in between. Smaller development sites within the city are just as likely to produce Roman material.

Evidence of Neolithic and Bronze Age activity, reaching back as far as 3500–4000 BC, is scattered over the general area of the modern city. These finds mostly represent the remains of small farming communities and the burial places of their dead. By the Iron Age, the landscape was quite densely exploited. A series of large enclosures, or hill forts, were spaced across the area of the modern suburban spread. Wandlebury, on the Gogs overlooking modern Cambridge from the south, is long known to have been a hill fort. A similarly sized earthwork was recently investigated at Arbury. War Ditches at Cherry Hinton is badly damaged by quarrying but appears to have been another, while a length of massive ditch at Marion Close (Huntington Road) may be a fourth. Borough Hill, Sawston, lies just outside the modern boundary. These enclosures were dug in the fifth/fourth centuries BC and overlapped in their use. They had all been abandoned by around the start of the first century BC. Neither was Castle Hill itself a greenfield site. It had been occupied during the late Iron Age but was apparently disused by the time the Romans arrived.

Rome knew the value of a good communication network and was quick to recognise the strategic importance of the river crossing at what we now call Cambridge. Not long after the Conquest, two new roads were laid across the region. The road from Godmanchester (Durovigutum), known as the Via Devana, made for the river crossing at the foot of Castle Hill before striking south-eastwards along a gravel ridge towards the important colonial settlement at Colchester (Camulodunum). Recent excavation has largely confirmed that the current Huntingdon Road followed the course of its Roman predecessor out of the town, as lengths of metalling were discovered in the grounds of Murray Edwards College, running parallel to the modern road, as well as on the approach to the river at Chesterton Lane Corner. It is likely that a wooden bridge was erected as part of this road-building programme. Across the river, the road probably followed the line of Bridge Street and Hills Road towards the Gogmagog Hills, where it is preserved in a field track.

The second road, Akeman Street, ran to the north of the river, branching off Ermine Street to the south and continuing northwards to a possible junction with the Fen Road heading eastwards from Peterborough into East Anglia. (These road names were given by antiquaries.) These two roads crossed, making the summit of Castle Hill a minor junction

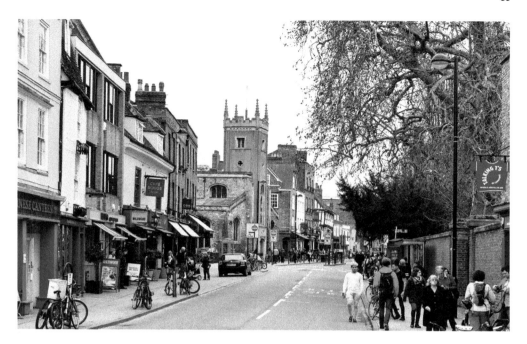

Bridge Street preserves the line of the Roman Via Devana.

on the road network. Initially, the new roads had a military purpose, but as peace covered the province they developed as commercial arteries. Cambridge's importance was further enhanced by being the lowest bridging point of the Cam and probably also the navigable limit for seagoing vessels.

Excavation revealed a short section of ditch of military type at the base of the Roman sequence. This was tentatively interpreted as a small fort, possibly built to control the crossroads and river crossing in the wake of the Boudiccan revolt of AD 60. If this identification is correct, it did not remain in use for long as it was levelled early the following century. Almost immediately, a small roadside community consisting of simple wattle and daub houses gathered around the crossroads, providing services for travellers. A number of lanes were laid out at right-angles to the main road, leading to houses and yards. A 'grand' building, which was clearly intended to catch the eye, fronted the Via Devana. It boasted a cellar, painted walls, mosaic floors and a tiled roof, though these features disguised its basic timber structure. The only building of quality stood at the northern edge of the settlement. Built of stone, with walls of painted plaster, a hypocaust (underfloor heating) and bath house, it may have been a *mansio* or rest house for imperial messengers and officials.

The civil settlement on Castle Hill continued, if it did not thrive, throughout the Roman period. A major change occurred in the fourth century AD when a wall, fronted by a ditch and backed by a bank, was built around the top of the hill. The enclosed area was not densely occupied and included yards, gardens and old gravel pits. It is uncertain why such an expensive project was undertaken, but this was a period of instability across the

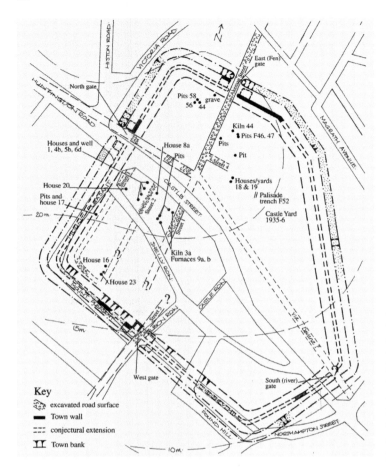

A plan showing the fourth-century defences of the Roman town. (Reproduced by permission of the Cambridge Antiquarian Society from *Proceedings of the Cambridge Antiquarian Society*, Vol. 88, 1999, p. 60)

Empire and many towns were first walled around this time. The wall was pierced by four gates, though the southern or river gate has not yet been located. One gate stood where Albion Row meets Mount Pleasant, another just south of the Huntingdon Road/Victoria Road junction, and a third lies beneath the castle. Nothing of the Roman town can be seen above ground, but the curve of Mount Pleasant, at the entrance to St Edmund's College, echoes the western corner of the defences.

The settlement across the bridge may have been regarded as a suburb of its neighbour on the hill. If so, it seems to have been more successful than its parent. Already in the later first century AD, occupation was spreading along the street frontage on the line of Bridge Street. There is limited evidence of pottery manufacture on the edge of the settlement in the following century. There may also have been facilities for shipping, with simple wharves downstream of the bridge, though to date no hard evidence of either a bridge or wharves has been identified. The fourth-century defensive work around the hilltop was not extended to the suburb 'on the wrong side of the river', but cemeteries in Jesus Lane and Park Street indicate that it continued to prosper.

This bend in Mount Pleasant closely follows the curve of the Roman town defences.

The Roman defences ran along Honey Lane. (© Andrew Sargent)

The settlement barely seems to merit the title of 'town', lacking almost all the normal urban features and with no evidence for the usual administrative functions. However, the name Duroliponte is found in lists of routes and mileages. Scholars suggest this name is not derived from the Latin for 'bridge' (*pons*), but from a native word meaning a 'boggy river valley'. Perhaps it is not surprising if an important river crossing preserved its ancient name.

The relationship between the Roman town and its medieval successor was not direct, as the archaeological evidence points to a substantial period of disuse. After 350 years of imperial rule, in AD 410 the province of Britannia was left to look to its own defence in the face of raiders from the east. Many of the civilised Roman arts were rapidly forgotten. Money, administration and civic life were all now irrelevant, resulting in towns being abandoned as an unnecessary luxury. Building in stone ceased, and in some parts of Britain even pottery seems no longer to have been made. One of the earliest English poems, 'The Ruin', tells of a Saxon wandering, awestruck, through the ruins of a Roman town, thought to be Bath. Cambridge was equally ruinous. The Venerable Bede, in his *History of the English Church and People*, records that when the monks of Ely needed a suitable stone coffin in which to rebury their saintly abbess Etheldrida in AD 695, they knew exactly where to look. They sailed to 'a small abandoned city' nearby, known as Grantchester (confidently identified as Cambridge), where they found a beautiful white marble coffin, complete with lid, outside the town walls. It was clearly exhumed from the Roman extramural cemetery.

Bede's anecdote is supported archaeologically. For the long centuries following the collapse of the empire, very little evidence of activity has yet been found within the old walled town or the area of the later medieval town on the opposite bank: a few pottery fragments, a brooch, the skeleton of a male minus his feet, which dates to around the end of Roman rule. This is not to say that the region was unoccupied. Even when the settlements of the living prove elusive, the cemeteries of the dead are evidence that life went on.

Things to See
-The curve in Mount Pleasant outside St Edmund's College roughly follows the north-west corner of the fourth-century town defences.
-Bridge Street–Regent Street follows the line of the Via Devana.
See also Walk 1.

3. The Town by the Bridge

In the confused years following the withdrawal of Roman power, Britannia descended into anarchy, and the pagan Saxons (a catch-all for the different Germanic and Scandinavian groups that saw opportunity in this comfortable, helpless land) emerged as rulers. The walled town of Duroliponte was left to fall down. Instead, the population lived in small communities or farmsteads close to the land on which they depended for their livelihood. As their buildings were ephemeral timber structures, unlike the masonry and brick of the preceding Roman period, they are difficult to identify. Only as the centuries pass do the Saxons become more visible to archaeology.

In the absence of settlement evidence, substantial cemeteries and scattered burials demonstrate that the people were there, somewhere. A fifth- to seventh-century pagan Saxon cremation cemetery lay beneath St John's College playing field at the north end of Queens' Road, while nearly 100 inhumations and 130 cremations have been recovered from the grounds of Girton College. A large cemetery was recently excavated in Cherry Hinton, while smaller cemeteries and individual burials are known elsewhere.

New evidence is beginning to paint a picture of a wide scatter of successful farming communities with no obvious administrative or market centre: there was at this time no Cambridge! A sixth- to seventh-century settlement, laid out as a single line of buildings, was excavated between Sidgwick Avenue and West Road. The central structure appears to have been the hall of a local chief. A cemetery in the garden of King's College Garden Hostel, across West Road, may possibly be where this community buried their dead. Another, apparently very ordinary, farming settlement has been investigated at Trumpington Meadows. However, appearances proved deceptive. When the grave of a teenage girl who had died in the mid-seventh century was excavated, it was found she had been buried with a brooch or pendant in the form of a cross, making this one of the earliest Christian burials so far excavated for the Saxon period. More remarkable still, the pendant, which was just 34 millimetres in diameter, was made of gold and garnets. The value and quality of this piece of jewellery reveal a surprising connection between this apparently remote backwater and the aristocratic circle which included the royals of the (slightly earlier) Sutton Hoo burial or the Staffordshire Hoard.

These were unsettled and violent times. For much of the ninth century Danish raiders pillaged the country. The Anglo-Saxon Chronicle reports that part of their Great Army made winter camp at Cambridge in 875. This choice of location emphasises the strategic importance of the river crossing and confirms that the Cam was capable of handling the seagoing vessels of the day. What is not yet known is precisely where they made their camp – in the old walled town or along the gravel rise leading from the bridge? In either case, their longships must have been pulled up on the river bank. Notably, this was the first use of the place name Granta Brycge. This bridge, which was presumably of timber,

may have been newly built at what for centuries must have been a ford or ferry crossing – the Roman bridge had long since decayed. Its importance is underlined by the fact that it gave its name to the settlement and ultimately to the shire (the only county to be named after a bridge).

A small settlement must have gathered around the bridge to service the needs of merchants and travellers using the old road. Hard evidence is elusive, though stray sherds of pottery are occasionally found. More substantial remains were uncovered in a service trench at Chesterton Lane Corner, where the road to the bridge had been cut into by middle and later Saxon burials, themselves sealed under a pre-Conquest building.

Fragile peace was once again restored under the Treaty of Wedmore in 878 which left this river crossing within the Danelaw, the area of eastern England ruled by the Danes. When in 921 this region submitted to Edward the Elder, King of Wessex and son of Alfred the Great, he created a *burh* (a fortified place) at Cambridge which soon became the administrative centre of the newly formed shire. A royal mint was active from around 975; rare coins bear the inscription '*GRANT*'. It is possible Edward's *burh* reused the old walled town, but if that was the case the suburb on the opposite bank quickly developed, offering readier access to the river. The excavator described the area around the junction of Bridge Street and St John's Street as 'recognisably urban' by the mid-tenth century. This Saxon settlement grew up around two streets, which still provide the framework for the town centre. The old Via Devana ran through the walled town to continue along the line of modern Bridge Street and St Andrew's Street, while a second

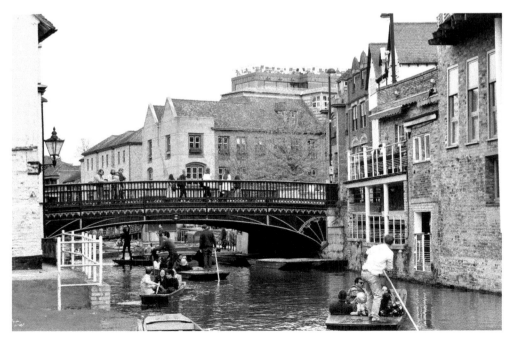

Magdalene Bridge gave the town its name. Roman, Saxon and medieval bridges have come and gone. The present bridge dates from 1823.

major street branched off to the east along what is now St John's Street and Trumpington Street. These central streets were lined with regular tenement plots, suggesting a degree of town planning, and the area between them was the natural site for a marketplace.

Perhaps eight churches existed by the time of the Norman Conquest. Their distribution indicates that most of the well-drained gravel tongue occupied by the medieval town was already settled, and this is confirmed by the pits and other features which are widely found during development work. Not surprisingly, the oldest building in Cambridge is a church: the tower of St Bene't's. Typical long-and-short work can be seen at its corners, while internally the capitals of the tower arch are carved with crouching lions. It is thought to date from the first half of the eleventh century, though it has been suggested that the stone church of which this is the surviving remnant may have replaced an earlier wooden building. The other possible pre-Conquest churches, since either rebuilt or demolished, are All Saints by the Castle (demolished), St Clement's (rebuilt), St George's (demolished – the Round Church was erected in its graveyard), St Andrew the Great (rebuilt), St Edward's (rebuilt), St Botolph's (rebuilt) and Little St Mary (rebuilt). Almost no Saxon stonework survives at these sites.

At some point the lower town was defended. A ditch, known as the King's Ditch, formed the town boundary throughout the medieval period, with the Cam completing the circuit. It would be appropriate to assume an internal earthen rampart and palisade. This Ditch followed a natural depression, perhaps an ancient river channel. Beginning at the millpond, it ran beside Mill Lane and Pembroke Street, before cutting across the New Museum Site and passing close to the west end of the Church of St Andrew the Great,

The Saxon tower of St Bene't's Church is the oldest structure in Cambridge.

A carved lion crouches on either side of the Saxon tower arch in St Bene't's.

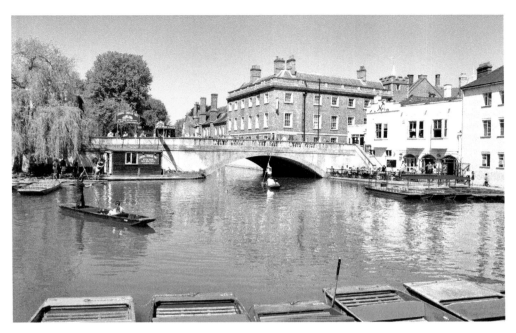

The millpond is named after the King's and Bishop's mills, recorded in Domesday Book. The King's Ditch started here, and Silver Street Bridge replaces the Small Bridges.

then continuing beside Hobson Street, passing through the grounds of Sidney Sussex College to rejoin the river opposite the Pepys Library of Magdalene College. In this way it enclosed an area of roughly 20 hectares. Although its course is largely fossilised in the street plan, all that is visible on the surface is a shallow depression in the Fellows' Garden at Sidney Sussex (not open to the public).

The origin of the King's Ditch is lost. The first tantalising mention in historical documents was not until 1215 when King John ordered it to be emptied of rubbish and made ready, implying it already existed. There have been few opportunities to investigate the Ditch archaeologically. Construction trenches in 1893 for the University Press Pitt Building on the corner of Mill Lane found a substantial ditch dated by late Saxon pottery, while an excavation in 2007 at the Grand Arcade suggested that section had first been dug in the eleventh century. Though a pre-Conquest origin seems probable, it may have been re-dug and cleaned many times. A historical event on which to hang the significant initial investment remains elusive.

Things to See
-The King's Ditch. (See also Walk 2)
-The seventh-century gold and garnet cross from Trumpington is displayed in the Museum of Archaeology and Anthropology, Downing Street.
-The tower of St Bene't's Church, Benet Street, the oldest structure in Cambridge.

4. Before the University

Following their victory in 1066, the Norman rulers acted swiftly to secure their new possessions. Within two years, a motte-and-bailey castle of earth and timber was thrown up inside the old walled town. In the process twenty-seven houses were swept away. Its 40-foot-high motte still stands on the top of Castle Hill next to the Shire Hall, where its grim and commanding presence must have been a constant reminder to the townsfolk of their subject status. By the thirteenth century, now lacking a military role, the castle was being used as a prison. Its condition became so bad that in 1285 five escaped prisoners sought sanctuary in the neighbouring church of All Saints. In 1283, Edward I began a programme of rebuilding it in stone which was not completed until the end of the century. The accounts reveal that around £400 a year was spent on the project – a significant sum – at times employing over 100 workmen. However, it was already effectively redundant, and from 1441 parts of the castle were pulled down to provide materials for King's College. Despite this, the administration of the shire continued to be based there until 1747.

The Cambridge the Normans inherited was an ordinary market town, similar to many in the region. The Domesday Book records at least 373 houses (one ward was omitted from the account) of which forty-nine were 'waste' (i.e. unoccupied), with an estimated

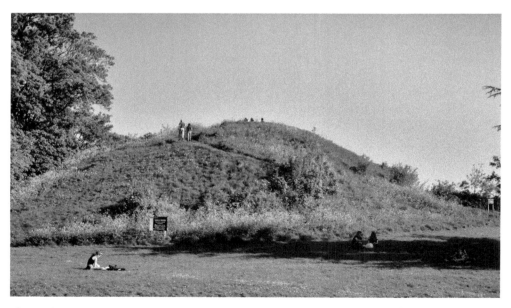

The earthen motte of the first Norman castle offers wide views over the town. Other castle buildings lay beneath the Shire Hall and car park.

population of 2,000. It was a bustling, prosperous place, a long-established regional centre which profited from long-distance, and even international, trade connections. Grain and fish were important export commodities. A market was held by ancient custom. Behind the street frontages, back yards and garden plots were often used for small-scale craft or industrial activity. The usual range of merchants and craftsmen served local needs for food and drink, clothing and household goods, as well as luxury items, and its shops or permanent stalls (seventy-six in 1279) were mostly in the market quarter.

The marketplace, extending over the modern market and Peas Hill, was the focus of civic life. The livestock market in Corn Exchange Street, then called Slaughterhouse Lane, abutted the King's Ditch, which was used illicitly for waste disposal. The Tolbooth stood in the middle of the marketplace, probably with the Guildhall on the first floor. A more fitting Guildhall was built in 1386, with an arcaded area beneath for stalls; the old Tolbooth became the town gaol. A market cross, stocks and pillory, a fountain or public pump, and a ring for bull baiting completed the facilities. The rest of the space was crowded with temporary stalls, with areas designated for particular commodities: corn, fish, milk, cheese, butter, oats, peas. Some of these stalls became permanent structures and even streets, for example, Combers Lane and Smiths Row built up against St Mary's Churchyard. Gradually, the open space was encroached upon. It was not until 1849 that a disastrous fire presented the opportunity to remodel on a more generous scale.

A large and prosperous Jewish community occupied the triangle between St John's Street and Sidney Street; the church of All Saints, now demolished but which is remembered in All Saints Passage, was described as 'in the Jewry'. In 1275 the Jews were expelled from all the towns held by the dowager Queen Eleanor, those in Cambridge being deported to Huntingdon. This prefigured the expulsion of all the Jews from England fifteen years later.

Cambridge's dependence on the River Cam for its economic edge was recognised when Henry I granted the town a monopoly within the county for waterborne trade. The Cam found its way to the North Sea at King's Lynn, allowing seagoing vessels to penetrate deep into England. A number of wharves, or *hythes*, developed along the southern bank, their later names suggesting specialisation in certain cargoes, for example, Flaxhythe, Salthythe, and Cholleshithe (coal *hythe*?).

Fairs – a rare opportunity to buy non-local goods – were a vital element in the medieval economy and a source of revenue for their owners. Cambridge institutions were granted charters for four, by far the most important of which was Stourbridge Fair. King John granted the leper hospital of St Mary Magdalene the right to hold a fair on the neighbouring Stourbridge Common. River access helped to make this one of the most important fairs in England, and it was soon attracting merchants from all over Europe. Today, the site of the Fair is mostly built over, but is remembered in the street names Oyster Row, Garlic Row and Mercers Row.

Prosperity brought growth and, with it, overcrowding. Room was found for the growing population by subdividing and infilling. Multiple occupancy was common. Cambridge was fast becoming a town of narrow lanes and of yards or courts squeezed onto back plots. Many of these lanes have since been built over, while others continue as thoroughfares and contribute to the town's character.

Land reclamation also created space for expansion. Much of the low-lying area between the old High Street (the St John's Street–Kings Parade axis) and the river had been subject to flooding. Excavation in this area often reveals accumulations of soil which may represent either gardening over a long period or deliberate dumping with a view to reclamation. By the twelfth century it was sufficiently well drained for a road named Milne Street to be laid out parallel to the High Street, served by the new parish church of St John Zachary. Lanes ran down to the *hythes* on the river bank. Wealthy men were able to build substantial properties in this previously vacant area. When William Bingham founded Godshouse in 1439 as a training college for twenty-four scholars of grammar, his own large house in Milne Street provided a readymade college, while Edward II purchased the house of Robert de Croyland in King's Hall Lane as accommodation for thirty-two scholars. When this whole sector vanished beneath the new colleges, the ghost of Milne Street was preserved in the line of Trinity Lane and Queens' Lane. The area to the east of Magdalene Bridge also appears to have been reclaimed by deliberate dumping, with development beginning in the seventeenth century.

As the riverside town grew, the old walled nucleus around the castle declined into little more than a residential suburb. Other suburbs extended for a short distance beside the main roads outside the Trumpington and Barnwell Gates. Another road left the town along the line of Jesus Lane, crossing the King's Ditch and heading for the priory of Augustinian canons at Barnwell and the thriving settlement outside its gate. Beyond these tightly drawn limits were the common fields in which many Cambridge residents earned their livelihoods.

The School of Pythagoras, St John's College, is the oldest surviving private house in Cambridgeshire. Built around 1200, it was once home to the wealthy Dunning family. (© St John's College. By permission of the Master and Fellows of St John's College, Cambridge)

The ghost of Milne Street (now Trinity Lane) twists its way past Trinity Hall, Clare College and the Schools. It is picked up again in Queens' Lane.

The Great Bridge was both a contributor to the town's prosperity and a financial burden. Still made of timber, it periodically required costly repairs. On one occasion, in 1275, the Sheriff exacted a heavier than usual tax with a promise to rebuild in stone, but he did nothing. It became so unsafe that there were reports of carts falling into the river. The first stone bridge, designed by James Essex, was finally built in 1754 for the huge sum of £1,609, but within fifty years it was declared 'ruinous'. The present cast-iron bridge with Gothic detailing dates from 1823.

Small Bridges Street (modern Silver Street) led to Newnham. As the Cam left the millpond it divided into at least two channels which were crossed by the 'Small Bridges' (in contrast to the Great Bridge). Maintenance was again a problem, with the Carmelites of Newnham complaining that the crossing was often impassable in winter. The medieval solution was a bridge-hermit who begged alms for upkeep. A cast-iron bridge was erected in 1841, while the present bridge was designed by Sir Edwin Lutyens.

Secular and religious life were closely intertwined. Medieval Cambridge was rich in churches, with seventeen parish churches serving a population of perhaps 3,000. An unusual example is the Round Church – a legacy of the Crusades – founded sometime between 1114 and 1130 by the Fraternity of the Holy Sepulchre. Their church, modelled loosely on the Church of the Holy Sepulchre in Jerusalem, consisted of just the circular nave and ambulatory, probably with a short chancel. A century later the Fraternity had disappeared and the Round Church became a parish church in the patronage of Barnwell Priory.

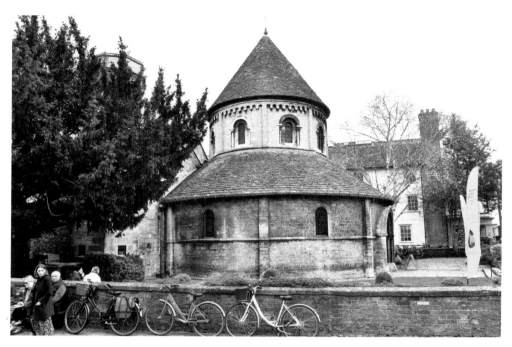

The unusual Round Church – the Church of the Holy Sepulchre – was inspired by the Church of the Holy Sepulchre in Jerusalem, which marks the traditional site of Christ's tomb.

One manifestation of popular religious life was the guild. Its objects were both devotional and social, providing welfare for members in need, burial rites and commemoration, and items for worship in the parish church. Over thirty parish guilds are known to have existed in the town at different times, though the ambition of two guilds far exceeded that of their rivals. Uniquely, the guilds of Corpus Christi at St Bene't's Church and of St Mary in the Church of St Mary in the marketplace combined in 1352 to found Corpus Christi College, making this the only college in Cambridge or Oxford founded by a guild – by the townspeople themselves.

The pre-university town supported a modest two religious houses and two hospitals, the latter offering spiritual solace rather than physical healing. In 1092 Sheriff Picot established a community of six Augustinian canons in fulfillment of a vow made by his wife Hugoline when she became ill at Cambridge. Picot's estates passed to Paine Peverel, who resolved to revitalise the priory and increase the number of canons to thirty. The existing site was cramped, so he petitioned Henry I for a piece of land not far outside the town, across the river from the royal estate of Chesterton. This plot already had religious credentials: a holy well, a ruined chapel and a hermitage. In 1112 the canons transferred to their new site, known as Barnwell Priory. Picot's church continued to stand at the foot of Castle Hill until the nineteenth century; two architectural fragments are incorporated into the Victorian church of St Giles.

The Priory of St Radegund, a house of Benedictine nuns, already existed when in around 1160 King Malcolm IV of Scotland, who was also Earl of Huntingdon, gave the

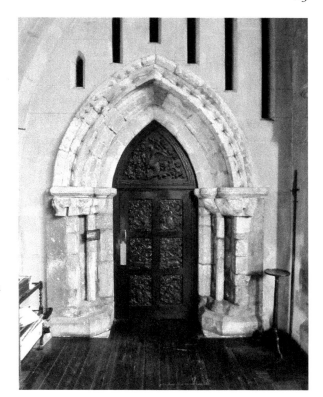

Right: This twelfth-century doorway in the north aisle of St Giles's Church is reconstructed from fragments from Picot's Priory, which stood on this site.

Below: The Cellarer's Chequer in Beche Road is a fragment of the Augustinian Barnwell Priory.

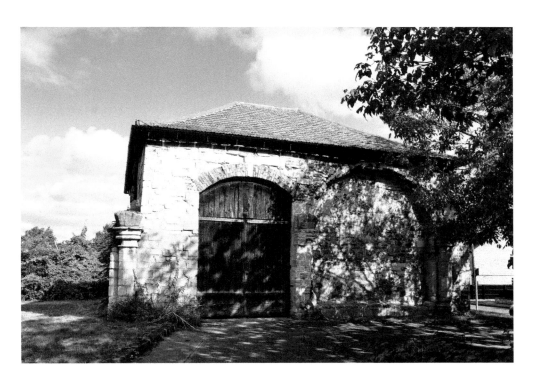

sisters 10 acres beside Midsummer Common on which to build their church. It was apparently Malcolm who added St Radegund, a royal Frankish monastic foundress, to the earlier dedication to St Mary. Despite Malcolm's example, the priory remained poor and dilapidated, providing Bishop Alcock with an excuse to suppress it in 1496 in order to found Jesus College.

Leprosy was rife in Europe. Sometime before 1150, the town burgesses founded a leper hospital, well to the east of the town beside the Newmarket Road. Its chapel dedicated to St Mary Magdalene still stands, described by Nikolaus Pevsner as 'one of the most complete and unspoilt pieces of Norman architecture in the county'. As leprosy died out, the burgesses regained control of their hospital and its revenues, foremost among them being rights over Stourbridge Fair.

The town founded a second hospital on a waste plot at the junction of Bridge Street and St John's Street. In this urban location, lepers were explicitly excluded. The Hospital of St John the Evangelist was in existence by around 1200, in decline by the end of the fifteenth century, and dissolved in 1511 at the request of Lady Margaret Beaufort in order to found her new college of St John. The thirteenth-century hospital chapel continued in use until the 1860s when a new college chapel was built by George Gilbert Scott.

The chapel of the former Benedictine nunnery of St Radegund was reused as Jesus College Chapel. (© Andrew Sargent)

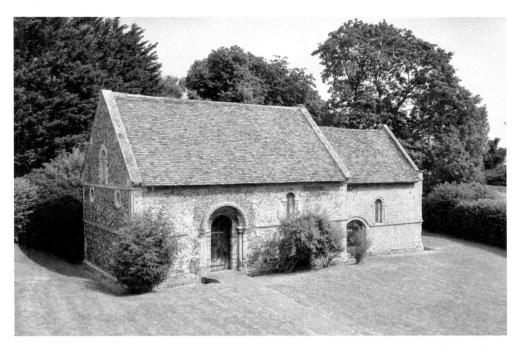

St Mary Magdalene, Newmarket Road, was the chapel of the Stourbridge leper hospital. (© Andrew Sargent)

Things to See

-A grassy mound at the top of Castle Street is all that remains of the Norman and later castle. It offers wide views.

-The eleventh-century chancel arch and a twelfth-century doorway from Picot's priory were reused in St Giles's Church.

-The unspoilt twelfth-century leper chapel of St Mary Magdalene is just beyond the railway bridge on Newmarket Road.

-The foundations of the thirteenth-century chapel of the Hospital of St John are exposed in the First Court of St John's College.

-The buildings of the former Benedictine convent still form the core of Cloister Court at Jesus College. The windows and doorway of the chapter house and the interior of the chapel are easiest to see.

-St Andrew the Less (Newmarket Road) and the Cellarer's Chequer (Beche Road), perhaps part of the kitchens, are all that can be seen of Barnwell Priory.

-The Round Church, at the junction of Bridge Street and St John's Street, is one of only five surviving 'round churches' in Britain.

5. A University Takes Root

The university begins with a date. A group of refugee scholars arrived in Cambridge in 1209. Earlier that year, town–gown tensions in Oxford had reached a new level when the civic authorities summarily hanged two scholars after a third had murdered his mistress and fled justice. In response, the masters voted to suspend teaching and dispersed; no empty gesture, this had an economic impact on the town's merchants. Some went to the established university of Paris, others travelled down the Thames to Reading, while another group found themselves in a market town in the Fens. Most of the Oxford scholars returned when the papal legate imposed a favourable settlement. The Cambridge contingent, however, chose to settle in their new home.

Cambridge offered several benefits to this first generation of scholars. As a town with no history of town–gown animosity, it must have felt refreshing. More strategically, two of the leading masters, John Grim and John Blunt, and possibly others, had previously been in the employ of the Bishop of Ely so may have hoped for his valuable patronage. On a personal note, the influential John Grim, who had been recognised by the pope as *magister scholarum Oxoniae* (head of the scholars of Oxford), had family connections in the town.

These masters were professional teachers, and their very survival demonstrates that they quickly attracted students. The masters banded together to form a craft guild dealing with matters of shared interest, such as an agreed curriculum and the awarding of degrees, just as they had done in Oxford. The university developed out of this guild structure. They owned no common property, hiring lecture rooms as required. The Church of St Mary the Great was recognised as the university church in which many formal events took place, while, later, the spacious church of the Franciscan friars was used to confer degrees.

Although there was as yet no visible university, it developed rapidly as an institution. As early as 1231, Henry III issued writs to promote the security and privileges of the scholars within the town, by implication crediting the chancellor and masters with the status of a legal corporation. Just two years later, Pope Gregory IX recognised Cambridge as a *studium* (a centre for higher studies) under the jurisdiction of the bishop of Ely. Finally, in 1318 a papal bull confirmed Cambridge as a *studium generale*, a university.

As the university gained recognition from powerful patrons, tensions with the town inevitably developed. It was a conflict of two jurisdictions, the civic and the academic-clerical, struggling to assert their respective rights within a single urban setting. All registered students were in minor religious orders while the teaching masters were priest – attendance at college chapel continued to be compulsory into the twentieth century – placing them under the authority of the ecclesiastical rather than the civil courts and therefore not subject to the town's justice. Although there were shared interests, disputes were often escalated to the highest authorities in order to win decisive concessions; for example, Henry III was involved in resolving the question of fair rents.

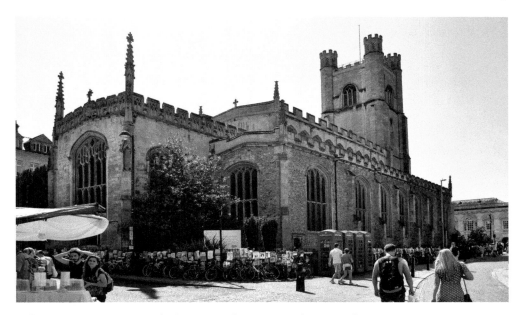

Before the Senate House was built, St Mary the Great was the setting for many university ceremonies and is still the University Church.

Maintaining law and order was another area of conflict. When a system of joint responsibility was negotiated in 1270, matters only got worse. Representatives of both parties were required to attend the *Magna Congregatio*, or Black Assembly, to swear to keep the peace and tranquillity of the university. It was further decreed in 1317 that annually, on taking office, the mayor and bailiffs should swear to uphold the privileges of the university. These ceremonies grew to symbolise the subordination of the town to the university and were a cause of great ill feeling. During the Commonwealth, the burgesses refused the oath, but it was reimposed at the Restoration and not finally discontinued until 1856.

Another event which helped to cement the university's ascendancy over the civic authority occurred in 1381. The Peasants' Revolt, led by Wat Tyler, appeared for a while to have won a new social order. In Cambridge, long-standing grievances were harnessed and the uprising took on a local flavour. Deep frustrations against the university were released. During Sunday mass, a crowd burst into St Mary the Great and broke open the university's strongbox there, seizing documents and items of value. They also broke into the Carmelite friary where the university kept a second chest. The rabble forced the university and college officers to renounce their privileges before surrendering their charters, which the rebels burned in the marketplace to cries of, 'Away with the learning of the clerks, away with it!'. However, the university was not the only target. The houses of several prominent burgesses were sacked, and the mayor was coerced into leading a 1,000-strong mob to Barnwell Priory where considerable damage was done. Once order had been restored and several ringleaders hanged, the town was punished by forfeiting many of its hard-won rights, while the university was granted jurisdiction in new areas, including the sale of food and drink.

The first property owned by the university was donated shortly before 1278 by Nigel de Thornton, a physician. It lay hidden away in a densely occupied district between the High Street and Milne Street. The university resolved to build its first lecture room on this site, eventually laying the foundation stone around 1347. (In this, Cambridge was well ahead of Oxford, where work on a purpose-built Divinity School was only begun in the 1420s.) Funds were short and progress was slow, with work continuing until 1400. The result was a modest two-storey structure of rubble. The Divinity School occupied the ground floor, with the university's chapel and the senate house (meeting room) above. It may from the outset have been conceived as one side of an enclosed quadrangle of Schools, but if so the scheme took another century to come to fruition. A west range followed in 1430–60, accommodating the School of Canon Law. The south range of 1457–70, built of the newly fashionable brick, housed the Schools of Civil Law and Philosophy with the university library on the first floor. Finally, the east range of 1470–74 was financed by Thomas Rotherham, Archbishop of York and Chancellor of the University. This range fronted the lane known as North Schools Street, and was pierced by the main gateway over which were displayed the royal arms and the arms of Archbishop Rotherham. This imposing façade reflected the growing position of the university. When the east range was demolished in the mid-eighteenth century to make way for a grander building, the entrance archway was rebuilt at nearby Madingley Hall.

The undergraduate curriculum of the medieval university concentrated on the arts. It was an exercise in listening and debating; few students had access to books. The course leading to the degree of master of arts took seven years and was in two parts. The *trivium* consisted of grammar, logic and rhetoric. This was followed by the *quadrivium*: arithmetic, music, geometry and astronomy. Latin was the language of both study and daily life. After gaining the MA, a scholar could choose to study civil or canon law or theology; the university did not have a strong reputation in medicine. Theology was held in highest regard, and a doctorate in theology was the pinnacle of academic attainment. The MA was also a title to teach the higher disciplines.

This traditional curriculum came under pressure to change in the later fifteenth century. The 'New Learning' of humanism, stimulated by the rediscovery of the ancient Greek texts, opened a world of ideas, but their adoption into undergraduate teaching was slow. In 1511, Cambridge achieved a coup when John Fisher, University Chancellor, invited his friend the leading humanist Desiderius Erasmus to teach theology and Greek. Erasmus lodged in Queens' College, though he appears not to have enjoyed his time there. Henry VIII was sympathetic towards the New Learning, founding chairs in divinity, Hebrew, Greek, physic, and civil law, and requiring each college to provide daily lectures in Greek and Latin.

The sixteenth century was a time of uncertainty and confusion. It dawned on an unquestionably Catholic country and set on a securely Protestant one, but the intervening journey was uncomfortable. Henry VIII's dynastic concerns found an ally in the religious changes of the Reformation; although Henry himself was religiously conservative, he was also a pragmatist. His son Edward VI and his councillors continued the drive towards Protestantism, before his elder daughter Mary turned the nation back to Catholicism. Finally, her sister Elizabeth sought stability and consensus, though once again under

a Protestant banner. This was a time for flexibility rather than conviction for men like Andrew Perne, Master of Peterhouse (from 1554 to 1589) and five times Vice Chancellor, a survivor, committed to his institutions but much criticised for changing his beliefs with the political climate.

Theology was more than academic. In the early 1520s, a group of scholars debated the new Protestant theology at the White Horse tavern (nicknamed 'Little Germany' after the German reformers) in Trumpington Street. Among them were two Austin Friars, Robert Barnes, their prior, who was later martyred as a heretic, and Miles Coverdale, a future translator of the Bible into English. Another young man with promise was Hugh Latimer, Bishop of Worcester under Edward VI, and burned at Oxford under Mary. Only one Protestant was martyred at Cambridge: John Hullier, who went to the stake on Jesus Green in 1556. That same year the corpses of two eminent Protestant theologians, Martin Bucer and Paul Fagius, were exhumed and publicly burned.

The university library provides a measure of the turmoil of the Tudor years. In 1529 the library held around 500–600 books; by 1557 only 175 remained – though this may be as much due to the routine weeding of out-of-date stock, coupled with a lack of investment, as to any official heresy-hunting. The library languished, unfunded and presumably unused. Its fortunes picked up from 1574, driven by the enthusiasm of the influential bibliophile Andrew Perne. Donors were found, books given, a library keeper appointed and the regulations revised. However, it still relied on gifts: the library did not buy its first book until 1617. Senior academics would have been only too aware of Sir Thomas Bodley's new university library at Oxford, while the Cambridge library still occupied only two first-floor rooms in the Schools.

At the same time, printing, a dangerous new technology, was strictly controlled. The limited market for printed books made the profession a risky investment, and in those turbulent times it was too easy to fall foul of changing orthodoxies. Few printers were licensed outside London. A private printer, John Siberch, struggled briefly in Cambridge in the early 1520s before returning to the Continent. It was not until 1534 that a royal charter empowered the university to maintain a press, and a further fifty years before the first book was published. Policy was to minimise financial risk by printing at arm's length. From 1583, generations of private printers were licensed to print on the university's behalf. The first was Thomas Thomas, a former fellow of King's College who married the widow of a wealthy local stationer. He sought a high profile, with premises at the heart of the university on University Street. His first venture may have been Pliny's *Historia Naturalis*, intended for the student market. Late in the following century, the university appointed a syndicate to oversee its licensed Press at a new site in Queens' Lane. The press, which bore the university's name, was only finally taken in-house in 1891.

Control of the large numbers of young men under its care was always a problem for the university, and one which often soured town–gown relations. The university progressively acquired powers intended to protect student morals but which seriously interfered with the life of the town. In 1317 the proctors were granted powers, confirmed several times, to search for and arrest 'loose women'. In the later sixteenth century, the vice chancellor was authorised to prohibit 'pernicious' games within 5 miles of the university, and was responsible for licensing alehouses in the town; in 1597 their number was reduced from

eighty to thirty, making them easier to police. The vice chancellor later licensed theatres and entertainments. In 1843 his jurisdiction was extended from 5 to 14 miles, taking in the neighbouring towns of Newmarket and St Ives.

Things to See
-St Mary the Great was, and still is, the University Church.
-Stand at the base of the tower of St Mary the Great and look along the line of the former University Street towards the Schools building.

In the 1830s the Pitt Building was belatedly designed to house the Cambridge University Press.

6. Hostels, Monasteries and Colleges

Today, Cambridge is almost synonymous with its colleges, yet the scholars had been settled in the town for seventy-five years before the first college was founded. At first they lived independently, renting rooms where they could. Student discipline, however, was a constant cause of friction with the townspeople as each generation explored their new freedom from parental control. Gradually, the hostel system developed to provide a more regulated environment for students sometimes as young as fifteen or sixteen. By the late fourteenth century, all students were required to be resident either in a hostel or in one of the new colleges.

There must have been hundreds of hostels over the years – the names of over 100 are known – and hostels continued alongside the established colleges, only gradually fading away. A hostel was a private commercial venture, and most were short-lived. They had to be registered with the chancellor and were inspected twice a year. A master was always principal, renting a house and subletting rooms, and taking responsibility for moral and academic discipline, perhaps with some teaching for his student-tenants. Consequently, hostels were usually just ordinary houses with little to indicate their use. Occasionally they were the former townhouses of wealthy families and were almost mini colleges in layout; for example, Physick Hostel, used as overflow accommodation by Gonville Hall, had previously been the home of the Fishwick family.

Friars and monks studying at the university were first to challenge this pattern of hostel provision, establishing centres of study (or *studia*) for their orders within the town. With their arrival, the university began to have a more visible presence. The newly created orders of preaching friars were quick to see the benefits of a university education in the fight against heresy. The Franciscans arrived in 1226 and were granted a property by the burgesses on the east side of Sidney Street, a former synagogue adjoining the house of Benjamin the Jew, which they shared with the town gaol. In due course they acquired the whole of the plot in the angle of Sidney Street and Jesus Lane with land on both sides of the King's Ditch, and their large chapel provided a convenient venue for many university ceremonies. The site is now occupied by Sidney Sussex College, though no friary buildings survive.

The Dominicans arrived a decade later, building their friary outside the Barnwell Gate. It was evidently well appointed, as it was chosen in 1388 to host the only meeting of Parliament to take place in the town. Following its dissolution in 1538, the friary was quickly broken up for building materials. Despite decades of quarrying, much of the former church remains hidden within the walls of the hall and fellows' parlour of Emmanuel College, while the clunch walls of the old library may also be Dominican.

Other orders followed. The Carmelite friars, the Gilbertine canons and the Augustinian (or Austin) friars all acquired sites in the town. At the Dissolution, the neighbouring

Looking north along Sidney Street. Sidney Sussex College (right) occupies the site of the former Franciscan friary.

colleges of Queens' and King's each bought a share in the former Carmelites' site: the north wall of the friary chapel forms part of their boundary. Nothing of the other two *studia* is visible. Last of this wave of monastic scholars, the Augustinian canons were late to appreciate the value of education. Successive Provincial Chapters debated how to provide for university study. They chose not to establish a hostel in Cambridge. Instead, despite being an inconvenient mile outside the town, Barnwell Priory served as their *studium*.

Meanwhile, a new concept, which was to change the face of higher education, emerged in Oxford in 1264 when Walter de Merton founded a college. There had been colleges before, but Walter's genius was to create a self-governing corporate body bound by statute: the institution itself could own property and conduct legal business. This conferred a new degree of stability. These first colleges differed from their successors in one important respect: they were communities of graduates only and did not admit undergraduates. Merton also defined the classic layout of a college around a quadrangle – or court in Cambridge terminology – with a gatehouse, a hall for common life, accommodation, and later a chapel and library. Despite superficial similarities in matters of ethos, governance and purpose, the new colleges were very different institutions from religious houses and their *studia*.

Walter de Merton's idea was quickly taken up in both universities. When Bishop Hugh de Balsham of Ely arranged, around 1280, for his handpicked band of scholars to be accommodated in the Hospital of St John the Evangelist, he instructed them to follow as far as possible the statutes laid down for Merton; perhaps he was already planning to found a college, and here was the blueprint. Two institutions sharing a single space

could only be an interim solution, and in 1284 Bishop Hugh transferred his scholars to two hostels adjoining the churchyard of St Mary the Less (then known as St Peter without Trumpington Gate) which belonged to the Hospital of St John, giving Rudd's Hostel in St Andrew's Street to the Hospital in compensation. The founding of Peterhouse, the first Cambridge college, is dated from this move.

Bishop Hugh's scholars owned only two hostels and a church, but with the eye of faith they began painstakingly to assemble a holding: this was a common challenge facing each new collegiate foundation. It was not until the sixteenth century that they acquired the property to the south, extending their boundary to its modern limits. The two original hostels dictated the layout of Old Court, which was set well back from the road behind a range of houses. The entrance was on the north side, between the college buildings and the church. The repurposed fourteenth-century gateway can still be seen from the churchyard. A hall, many times larger than required, was put up in 1290. The rest of the court, including the replacement of the hostels, had to wait until the fifteenth century. St Peter's was rebuilt around 1350 and served as the chapel until the college built one of its own in 1632, when direct access to Trumpington Street was also created.

It took another forty years before Bishop Hugh's example was followed. In 1324, Hervey de Stanton, Chancellor of the Exchequer to Edward II, founded Michaelhouse for seven scholars and a master. This quite extensive plot ran down to the river at the north end of Milne Street. It was later swallowed by Henry VIII's Trinity College and nothing of de Stanton's college remains. Then came a number of foundations in quick succession: University Hall (1326, refounded as Clare Hall in 1338), King's Hall (1337), Pembroke College (1347), Gonville Hall (1348, refounded in 1557 as Gonville and Caius College), Trinity Hall (1350) and Corpus Christi College (1352). King's Hall, like Michaelhouse, was absorbed into Trinity College, although in this case several structures do survive: the Great Gate with the ranges on either side, and another range hidden behind the chapel, date from this period, while King Edward's Tower against the west end of the chapel is the repositioned gatehouse of the earlier college.

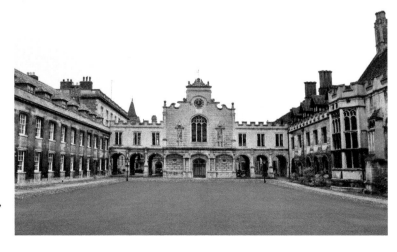

The great hall of 1290 (right) and seventeenth-century chapel of Peterhouse, Cambridge's first college.

Until the Old Court was opened to the
street, the entrance to Peterhouse was
via this gateway between the north
range and St Mary the Less.
(© Andrew Sargent)

The following century saw a renewed surge in foundations, beginning in 1428 with the
last of the monastic *studia*. The Provincial Chapter of the Benedictines acquired a plot beside
the Great Bridge, leaving individual houses to erect their own accommodation (a policy also
pursued at Gloucester College, their Oxford *studium*). Originally known simply as Monks'
Hostel, it was renamed Buckingham College after the 3rd Duke of Buckingham. King's
College (1441), Godshouse (1442), Queens' College (1448), St Catharine's College (1473),
Jesus College (1497), and St John's College (1511) followed. Godshouse was refounded as
Christ's College (1505) by Lady Margaret Beaufort, mother of Henry VII. Most of these new
foundations were along Milne Street, creating what might be termed a university quarter.

Although women could not study at the university – and would not be admitted for
several centuries – a strong few demonstrated their intellectual interests by founding
colleges. As well as Christ's, Lady Margaret founded St John's College. University Hall was
renamed in honour of Lady Elizabeth de Clare, granddaughter of Edward I. Pembroke
College was founded by Mary de Valence, Countess of Pembroke. Queens' College has
two royal foundresses, Margaret of Anjou and Elizabeth Woodville. Margaret of Anjou
explicitly founded her college 'to laud and honneure of sexe feminine' while her husband
was still formulating his grandiose plans.

Henry VI's ambition for King's College was on a different scale to his counterparts,
involving the wholesale remodelling of a significant part of the town. At first his plans were
modest, consisting of the single quadrangle of Old Court (backing onto the Schools) with

A doorway in Magdalene College, the former Benedictine *studium*. Heraldry identified which monastery built each block, though these arms are not original. (© Andrew Sargent)

A carving of Andrew Dockett, founder and first president, keeps watch over the entrance to Queens' College.

a small chapel adjoining. Work had barely started when he was persuaded to think on a much larger scale. The complex task of assembling the substantial plot, which is still King's College, took time. Milne Street itself was closed, as were the many lanes running down to the *hythes*; in one case, the town was compensated for loss of access to the Salt Hythe. The recently founded college of Godshouse had to move, and the parish Church of St John Zachary was demolished. Keeping the unfinished Old Court as interim accommodation, Henry began to build anew, starting with his chapel. This was on the grandest scale and remains one of the architectural glories of Cambridge: 289 feet long, 40 feet wide, and 80 feet high internally to its vaulted ceiling, and with twelve immense windows down either side. The foundations of a freestanding bell tower show up in the lawn in dry weather. Inevitably, the project struggled for want of resources. The chapel was only completed by Henry VIII in 1515, while Henry VI's scheme for a vast court has never been fully realised.

The Reformation caused seismic change in both the university and the town when, in 1538/39, Henry VIII dissolved the monasteries, including their *studia*. The religious orders had been a part of the university for 300 years. Now, at a stroke, the university and town emptied of monks and friars. Many were pensioned off, while others were appointed parish priests elsewhere. Their vacant properties became convenient quarries for building materials.

The colleges had barely escaped these shattering closures when the Chantry Act of 1545 posed a new threat, appointing commissioners to investigate the financial probity of a series of religious institutions including chantries, colleges, hospitals and guilds.

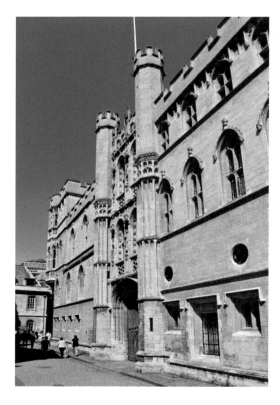

The gatehouse of King's Old Court (now the Schools) opens into Trinity Lane, the former Milne Street.

This process came to an abrupt end with Henry's death in 1547, but any relief was short-lived. That same year, Edward VI passed a revised Chantry Act, which proclaimed prayers for the dead to be superstitious. Although colleges were academic institutions, part of their purpose as communities of men in holy orders was to pray for the souls of their benefactors. This firmly placed them alongside chantries. However, the new Act was careful to protect, where possible, genuine charitable activities undertaken by these institutions. This category included education, allowing the colleges to justify exemption.

Even while he was drafting this legislation, Henry VIII conceived the idea for a substantial new foundation, Trinity College, which would reflect honour on himself and his dynasty; his statue presides over the main gate. The precedents for such grand statements were not encouraging: Henry VI's ambition for King's College had overreached itself, while Cardinal Wolsey's exercise in pride (eventually reworked as Christ Church, Oxford) had foundered with his career. The foundation charter of Trinity, dated 1546, provided for a master and sixty scholars, with a generous endowment of former monastic lands. The existing colleges of King's Hall and Michaelhouse surrendered to Henry, who initially adapted their buildings as the core of his new college. Physick Hostel was purchased from Gonville Hall. Henry gave building stone from the former Franciscan friary, but progress was slow. Great Court only achieved its present form under the mastership of Thomas Nevile (1593–1615), who added Nevile's Court at his own expense.

A surprising survivor of the Dissolution was the Benedictine *studium* of Buckingham College which clung on until 1542, when it gained a degree of security by being refounded as the secular Magdalene College. It was a ready-made college, though its main court remained open towards the street. A generous benefactor, Sir Christopher Wray, paid for the final range in the 1580s.

By the end of the century, two new colleges had appropriated the sites of former religious houses. Sir Walter Mildmay founded the Puritan Emmanuel College in 1584 on the site of the Dominican friary. Lady Frances Sidney, Countess of Sussex (another foundress),

Trinity Great Court. The clock tower is the repositioned gatehouse of King's Hall; the chapel was built during the reign of the Catholic Mary; the ornamental fountain dates from 1601–15.

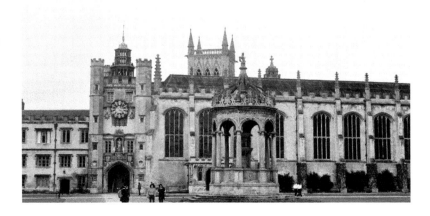

established Sidney Sussex College in 1594 on the former Franciscan site. They were the last new foundations for two centuries, though the existing colleges continued to build and expand. Numbers attending the university climbed, until by around 1620 there may have been as many as 2,000 resident members.

Things to See
-The older colleges are all gems.
-Peterhouse was the first college in Cambridge. Its hall dates from 1290.
-It is unthinkable to visit Cambridge and not see Henry VI's King's College chapel. A well-timed visit will allow you to hear evensong.
-The restored gatehouse of the former Old Court of King's College opens onto Trinity Lane, a fragment of Milne Street.
-Three quarters of the First Court of Magdalene College consists of the reused buildings of Buckingham College, the only monastic *studium* in Cambridge to survive.
-Trinity College Great Court, the largest enclosed college court, preserves buildings from the earlier King's Hall.

Triumphant students at Gonville and Caius College still process through the Gate of Honour, which opens into Senate House Passage, to their degree ceremony in the Senate House.

7. Politics and Architecture

The national confidence from which the university had benefitted through the reigns of Elizabeth and James I quickly evaporated under Charles I. Charles's theory of kingship made him inflexible in his dealings with Parliament, leading inexorably towards civil war in 1642. As the nation's opinions polarised, Cambridge, like the rest of the country, was divided. The town was generally Puritan and for Parliament – Oliver Cromwell had been MP for the borough – while the university was high church and Royalist in sympathy.

Charles's Archbishop of Canterbury, William Laud, pursued his monarch's high church agenda. Laud set out to beautify the public worship of God. 'Innovations' were introduced, for example, altars with hangings and candlesticks replaced plain communion tables, and rails marked out the altar which was raised on a dais. In line with this thinking, many college chapels adopted rich decorative schemes, new furnishings and choral services. To some this was beauty and reverence, to others, a reintroduction of 'popery'.

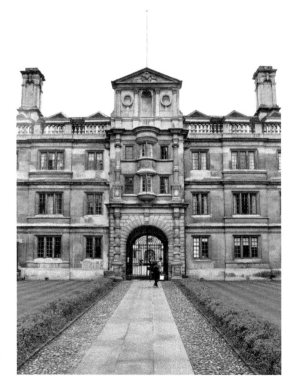

The symmetrical entrance front of Clare College, entirely rebuilt in the seventeenth century.

Parliament was concerned at these high church developments. Despite the turmoil of civil war, it found time in 1643 to pass an ordinance for 'the utter demolishing, removing and taking away of all monuments of superstition and idolatry'. The Earl of Manchester, Captain General of the Parliamentary Armies of East Anglia, commissioned William Dowsing, a Suffolk farmer and convinced Puritan, to oversee compliance with this ordinance in East Anglia. Dowsing kept a journal. He was only in Cambridge between 21 December 1643 and 2 January 1644, but in that short time he visited every town church and college chapel, sometimes 'cleansing' as many as four in a day. In Pembroke College chapel, for example, he pulled down eighty 'superstitious pictures' and broke ten cherubim; at Jesus College, he dug up the altar steps and broke down at least 120 superstitious pictures of saints and angels. Many of these 'pictures' and cherubim were on hangings and paintings or in stained glass. He often complained of passive resistance: the fellows of Queens' refused to put on their hats in the cold chapel as they stood by to witness the destruction. At Trinity College, the organ blower, Mr Chambers, continued to receive his salary for the next two years despite the organ having been removed. A few colleges were Puritan in their sympathies. Dowsing found nothing to complain about at Sidney Sussex (Cromwell's old college – where his severed head is still preserved), Emmanuel or Corpus Christi colleges. The churches did not escape. Steps were dug up at St Botolph's, eighty 'popish pictures' were broken down at Holy Trinity, and steps were dug up and forty pictures and ten inscriptions taken down at St Edward's. Surprisingly, St Mary the Great escaped without censure. Antiquaries have lamented this wholesale destruction of religious art.

Being in a strongly Parliamentarian region, Cambridge was the natural headquarters for the Eastern Counties Association. To safeguard this strategic location, Parliamentary forces seized the castle and by March 1643 defensive earthworks were under construction, towards which the townsfolk were invited to make a 'free will offering'. Loggan's town plan of 1688 shows the classic star shape of an artillery fort around the castle. A cannon was positioned to command the bridge. Although Cambridge was fortunate to be bypassed by military action, there was a brief flurry of concern in 1645 when Royalist forces took Godmanchester. The danger passed; the following year the defences were slighted and the garrison withdrawn.

Several colleges sent silver in answer to the King's plea for aid, though their gifts were sometimes intercepted and five heads of colleges were imprisoned for their loyalty. Royalist and high church academics were rooted out, with over 200 fellows, half the total, being ejected and Parliamentary appointees installed. All members of the university were required to swear to the Solemn League and Covenant. In this political and intellectual climate, student numbers plummeted.

The restoration of the monarchy under Charles II triggered a fresh flood of self-confidence which was manifested in prestigious building projects, and student numbers briefly rallied. In 1663, the architect Christopher Wren was engaged to build a chapel at Pembroke College. This, Wren's first commission in Cambridge, was financed with a gift to the College from his uncle, the Bishop of Ely. He subsequently designed a new chapel for Emmanuel College. In 1676, Wren, by now engaged on St Paul's Cathedral, began work on the Wren Library in Trinity College which completed Nevile's Court. This is imaginatively raised on an open colonnade in order to preserve the views to the river.

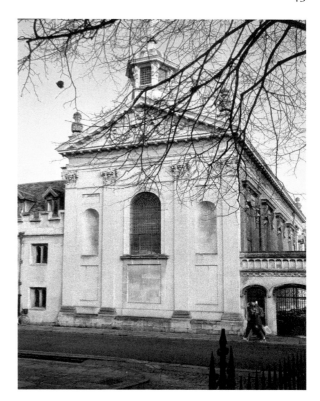

Right: Pembroke College chapel was Christopher Wren's first Cambridge commission.

Below: Trinity College library was designed by the mature Sir Christopher Wren.

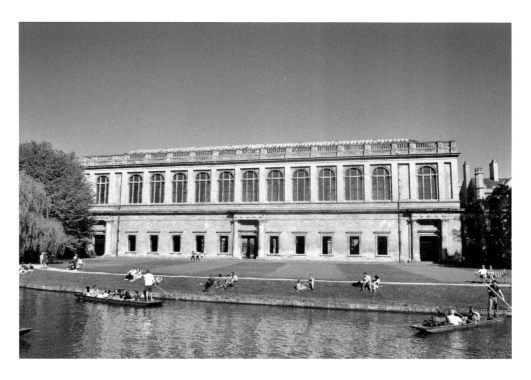

Throughout the succeeding century, numbers at the university continued at a low level. Its curriculum seemed increasingly old-fashioned and irrelevant, and to the chagrin of many students, mathematics was dominant. The fellows gained a reputation (not always deserved) for being 'sleepy, drunken, dull, illiterate Things', to quote the poet Thomas Gray. Undoubtedly there were those among them who were active in research or committed teachers, but many felt that, having worked hard to win their appointments, it was their right to enjoy the fruits of their labours. Their lead was followed by the undergraduates. Students were classified as Hard Reading, Reading and Non-Reading Men; many had no intention of taking a degree, while the sons of noblemen received honorary degrees. Those with an eye to a fellowship had to study hard and employ private coaches, while the majority got away with little mental exertion.

With a significant proportion of the undergraduate body not studying seriously, discipline was a problem. A code issued by the chancellor in 1750 indicates the areas of concern. Students were forbidden to play sport or attend coffee houses in the mornings, running tabs in taverns were capped, no student could keep a horse or ride out of Cambridge without permission, guns and sporting dogs were forbidden, and a curfew of 11 p.m. was imposed.

Architectural ambition, however, remained undimmed, though there was a philosophical battle between the 'progressive' Classical/Palladian and 'conservative' neo-Gothic styles. The first decades of the eighteenth century saw attempts to complete

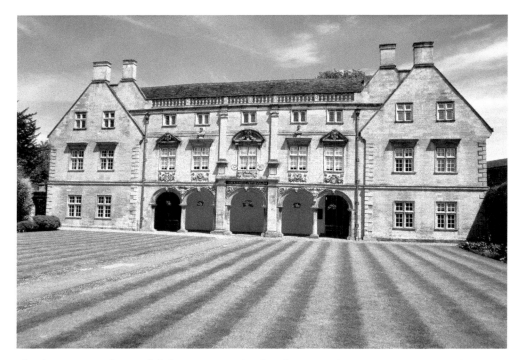

The diarist Samuel Pepys left his important book collection to his old college of Magdalene. It is housed in the Pepys Building. (© Andrew Sargent)

The view along the tree-lined avenue from Trinity New Court towards the spire of Coton Church (behind the photographer) was famously likened to a college fellowship, 'a long dreary road, with a church in the distance', a reference to the fact that fellows often retired, married, and became country parsons.

King's College on a grand scale. In 1713, Nicholas Hawksmoor, Wren's protégé, prepared a design that was rejected, as was his more far-reaching plan to remodel the town centre in the baroque style. Then James Gibbs's scheme of 1724 was abandoned after just one range had been completed. By the end of the century, both Robert Adam and James Watt had also submitted plans. It was not until the 1820s that local architect William Wilkins's neo-Gothic design won a competition for the range, including the hall on the south side of the college. The provost's lodge and other buildings fronting King's Parade were removed to give a clear view of the east end of the chapel, and Wilkins's screen and porters' lodge created a new and distinctive frontage.

After more than two centuries that had seen no new colleges, Downing College was founded under the will of Sir George Downing, who died in 1749. The bequest was conditional on his heirs dying without legal issue. However, when his cousin, the 4th baronet, duly died in 1764 it took a protracted legal battle before the nascent college was able to secure its funding. A large patch of wasteland on the edge of the town, known as The Marsh, over which Henry Gunning recalled shooting for snipe in the 1780s, was acquired. William Wilkins was engaged, and the foundation stone was eventually laid in 1807. This time, Wilkins broke with traditional college architecture, designing instead a series of neo-Grecian pavilions grouped around a huge lawned court. Only part of the scheme was ever realised, but the result is still striking. The unfinished court was finally closed to the north in the mid-twentieth century. William Wilkins was also responsible for New Court at Trinity College (1823–25). The dramatic New Court of St John's College by Rickman and Hutchinson (1825–31) was the first college building to be erected on The Backs.

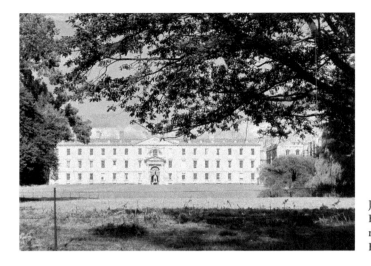

James Gibbs's building at King's College. He was also responsible for the Senate House.

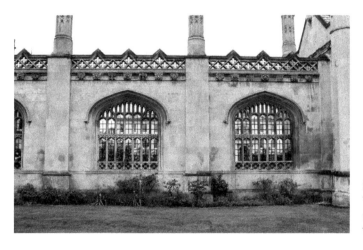

Local architect William Wilkins designed the iconic screen and porters' lodge, which front King's Parade.

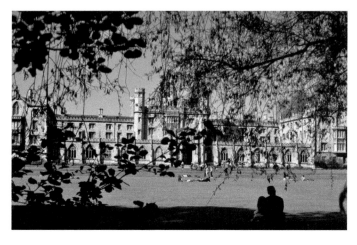

New Court (built 1825–31), St John's College, was the first college building on The Backs. (Reproduced by permission of the Master and Fellows of St John's College, Cambridge)

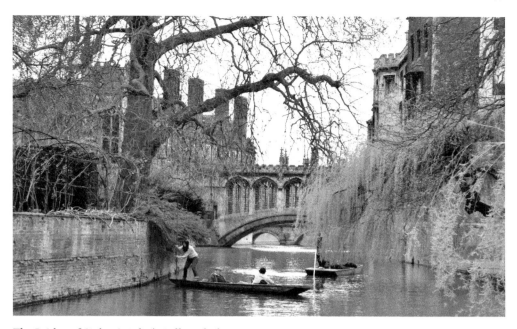

The Bridge of Sighs, St John's College, links 1820s New Court with the old college.

While the colleges were proclaiming their importance in bricks and mortar, the university had been left behind. The Schools, at its administrative heart, were still hidden behind a jumble of tenements. A statement more in keeping with its status was needed. In 1574 the area between the Schools and Great St Mary's on the High Street was bought up and a ceremonial link between these two important buildings, known as University Street, was created. However, something grander was required. Christopher Wren's detailed design for the area in front of the Schools, consisting of a Senate House and arcaded ranges around a court, came to nothing, as did a scheme by Nicholas Hawksmoor. Finally, the Senate House was built at right-angles to the Schools. Begun in 1722 and taking eight years to complete, it was designed by James Gibbs in a classical style. Its prominent south and east façades of white Portland stone are capped by pediments supported on giant pilasters and columns. Internally it is one large room with an antechamber. Galleries run around three sides, with a dais at the west end and a chequerboard floor of black and white marble. Many university ceremonies were transferred there from the neighbouring St Mary the Great. Gibbs intended his Senate House to be one side of a court open towards St Mary, but objections were raised and the project was halted. One concern was that the proposed southern range would block the view of King's College chapel, a view which is still preserved today. This left a clash of architectural styles between the Senate House and the fifteenth-century east front of the Schools. The solution was to replace the east range in a more fitting Palladian style, undertaken in 1754–58 by Stephen Wright.

In 1816, Lord Fitzwilliam bequeathed an important art collection, together with £100,000 in South Sea Annuities with which to build a suitable museum. Plans progressed slowly. Meanwhile, the collection was displayed in the former Perse Grammar School in

The Senate House was built in 1722–30 as the venue for university ceremonies.

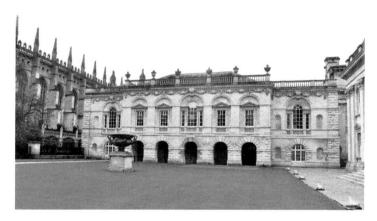

In 1754–58 the east range of the Old Schools was rebuilt in the Palladian style to complement the neighbouring Senate House.

Free School Lane. A site fronting Trumpington Street was purchased from Peterhouse and a design competition was won by the architect George Basevi. The first stone was laid in 1837; it was completed in 1848 after Basevi's death. This neo-Classical vision in white Portland stone is designed to over-awe, with its colonnaded portico and domed staircase hall. The Fitzwilliam Museum has since been extended several times to accommodate its growing, internationally-important collections.

In 1762, the university accepted a rather different gift when Richard Walker acquired the site of the former Austin Friary for a physic garden. The Botanic Garden was transferred to its current, larger site on Trumpington Road in 1846. The gate piers at the rear of the Engineering Laboratory on Fen Causeway, which face Coe Fen, formerly graced the old Botanic Garden.

New needs prompted new buildings. The University Observatory was built out along the Madingley Road in 1822–23 in a Greek Doric style. A new home for the University Press

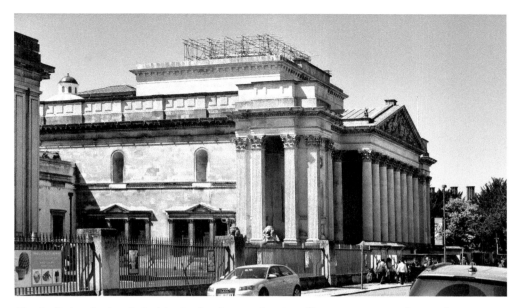

Classically inspired and of white Portland stone, the Fitzwilliam Museum was designed to impress.

was erected in 1831–33 on the corner of Trumpington and Silver Streets, using funds from an over-subscribed statue of William Pitt erected in London. Its tower is still a landmark, though the operations of the Press have moved out to the suburbs. The central university functions had long outgrown the Schools, so the Old Court of King's College was purchased as part of an ambitious scheme to sweep away the Schools-Old Court complex and replace it with a large quadrangle to house the university library, administrative offices, lecture rooms and museum space. C. R. Cockerell won the architectural competition with his stern neo-Classical design, though only the north wing of 1837–42, which abuts Senate House Passage (also created as part of the scheme), was ever built.

Things to See
-Pembroke College Chapel was Sir Christopher Wren's first Cambridge commission.
-Clare College saw a programme of rebuilding from 1638 to 1715. Despite the interruption of the Civil War, the result is delightfully harmonious.
-The Fitzwilliam Museum merits a visit for its collections of art and antiquities, as well as its architecture.
-Not all fellows were dullards! Roubiliac's 1755 statue of Isaac Newton 'with his prism and silent face' (Wordsworth, 'The Prelude') stands in the antechapel at Trinity College.
-The combined sun and moon dial in Queens' College Old Court, incorrectly attributed to Sir Isaac Newton, may date from 1642 but has frequently been repainted.

8. Towards a Modern University

The dawn of the nineteenth century found the university at a low ebb, with only 811 resident members in 1801. Its earlier reputation for being academically moribund continued unchallenged, while it was felt to be irrelevant in the new industrial and imperial era. Although numbers rose steadily towards the middle of the century, little else changed.

Impatient for reform, a Royal Commission was appointed in 1850. Its main concerns were to modernise university administration, to introduce new and relevant degree courses, and to enquire into college and university revenues. Its report recommended new triposes in engineering, modern languages, history and theology; Boards of Studies to co-ordinate teaching; an ordinary degree in each tripos; and new lectureships that would be part-funded by the colleges. State funding, with a corresponding loss of autonomy, would be needed to help with the cost of new laboratories and museums. Notably, the Commission did not recommend releasing fellows from the requirement of celibacy, neither did it advocate broadening access by accepting non-collegiate students. Further government enquiries were to follow.

Pressure for change now increasingly came from within the university, but it still battled inertia. Gradually, new professorships were established and triposes instituted. The teaching of physics and natural sciences was expanded, while mathematics declined from its earlier position of dominance. Lecture rooms and laboratories were erected on the site of the old Botanic Garden (now known as the New Museum Site), and the Cavendish Laboratory was funded in 1874 through the generosity of the Duke of Devonshire. Further teaching and museum facilities were soon developed on the opposite side of Downing Street.

Access remained a pressing problem. Quite apart from the finite number of places available, the additional costs of college membership were perceived to exclude many gifted young men from the new middle classes. To address these concerns, it was agreed that the university would accept students without a college affiliation. In 1869, a Board for Non-Collegiate Students rented the elegant Fitzwilliam House in Trumpington Street. Surprisingly, advertisements were placed in the press! One in the *Birmingham Daily Post* read,

Many parents who desire to give their sons the benefit of a University education, at moderate cost, will be glad to know that the University of Cambridge has made very liberal arrangements for the admission of non-collegiate students. Hitherto, students have been received only as members of some college at the University, but henceforth they will be allowed to keep terms by residing with their parents or in lodgings duly licensed, thus escaping the cost of collegiate residence. At the same time all the privileges of the University will be open to them.

Right: The entrance to the original Cavendish Laboratory site in Free School Lane. The laboratory has now moved to West Cambridge.

Below: Students relax in a grassy corner of the Downing Site.

Eight students were admitted in that first year. After almost a century, the Board itself became a full college under the name of Fitzwilliam College, moving to its current site on Huntingdon Road in 1963 and receiving its charter three years later.

There was a renewed interest in founding colleges. In 1882, Selwyn College was founded in memory of George Augustus Selwyn, first bishop of New Zealand and an Anglican hero. The architect Sir Arthur Blomfield delivered a traditional college plan in red brick. With an ethos based in Christian principles, it was intended for poorer students, and this was reinforced by imposing a termly limit on student expenditure. Despite its name, it was not technically a 'college' but was listed as a 'public hostel', only achieving full college status in 1958.

Two other collegiate experiments in the later nineteenth century lacked financial stability. Joseph Brereton set up County College on Hills Road in 1873 for younger students. The name was changed to Cavendish College in recognition of support from the Duke of Devonshire, but it failed in 1892. Then in 1884, William Ayerst, a former missionary and military chaplain, opened Ayerst Hostel for men of modest means studying at the university. The venture survived for only twelve years.

The opening of the university to those of all faiths or none was long overdue when the Cambridge University Act of 1856 relaxed the legal restrictions. These were finally removed with the repeal of the Test Acts in 1871. The Catholic hierarchy continued to discourage its members from attending the (Anglican) university until 1896, when the former Ayerst Hostel on Mount Pleasant was taken over as a hostel for Catholic students under the name St Edmund's House. Initially recognised only as a lodging house, it was granted full college status in 1998.

By the mid-nineteenth century, women's education was becoming an issue that was destined to change the university. Women had historically been excluded from Cambridge and Oxford universities and resistance to their admission was deeply entrenched. One leading campaigner was Henry Sidgwick, an academic who pursued reform in several areas of university life. In 1869 he organised a series of lectures in Cambridge

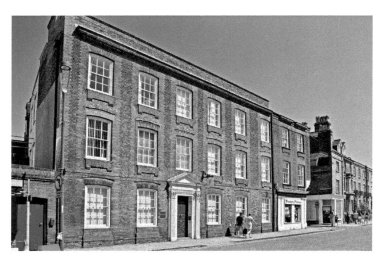

The Georgian Fitzwilliam House was the first home of the Board for Non-Collegiate Students, later Fitzwilliam College.

for women teachers. To support the programme, he rented suitable lodgings, first at 74 Regent Street and then Merton Hall, and invited the female educationalist Anne Clough, sister of the poet Arthur Hugh Clough, to be supervisor. This led to the founding of Newnham College by public subscription in 1875.

A parallel initiative was driven forward by Emily Davies. Her first action was to rent Benslow House in Hitchin, which opened with five students in October 1869. Lecturers travelled out from Cambridge by train. Miss Davies was realistic in her choice, as Hitchin's position on the railway would allow her to join with the new London University if Cambridge proved intransigent. However, Miss Davies and her trustees were soon planning a move to Cambridge, although she was adamant that their college should be outside the town to avoid wasteful social calls. A combination of fundraising and loans allowed fifteen students to move into the first of the new college buildings just beyond the town boundary at Girton in 1873, though the ambitious construction programme continued for the remainder of the century.

The university moved glacially slowly. At first, women were permitted to attend certain lectures, suitably chaperoned; then to take the men's exam papers, though they received no degree. The women felt they constantly had to prove their worth. Sensationally, in 1890, Philippa Fawcett of Newnham was classed 'above the Senior Wrangler' in mathematics – the top student in the flagship subject. Oxford University admitted women in 1919, but Cambridge resisted, compromising in 1922 by offering women the title of their degree though no actual degree. This fiction became increasingly untenable with the appointment of the first female lecturers in 1925 and the archaeologist Dorothy Garrod as professor in 1939. It was not until 1948 that women were finally admitted to full membership and awarded degrees.

Other initiatives for women's education were attracted to late nineteenth-century Cambridge. The Cambridge Training College for Women Teachers, established in 1885, focused on teacher training for female graduates. Under the name of Hughes Hall, it became in the 1940s a recognised institution for graduates of either sex studying for a higher degree, and a full college in 2006. Homerton College, a teacher-training college for women, moved into the buildings of the failed Cavendish College in 1894. It went mixed and became an approved society in 1976, and in 2007 a college offering the full range of university courses.

In the late eighteenth century, the evangelical Charles Simeon, fellow of King's and vicar of Holy Trinity, had organised informal lectures and sermon practice for prospective Anglican ordinands. With the professionalisation of the clerical calling, the new theological training colleges found in late Victorian Cambridge a conducive environment for study. The Anglican colleges of Ridley Hall and Westcott House both opened 1881. Westminster College for Presbyterians, with its imposing red brick buildings at the end of Queens Road, transferred from London in 1899. Cheshunt College moved to Cambridge in 1906, with premises in Bateman Street. Wesley House was established in Jesus Lane in 1925.

The twentieth century was a time of unprecedented growth for the university, despite the impact of two World Wars. College war memorials bear testimony to the heavy price paid by two generations of gilded youth. During the First World War, the First Eastern General Hospital commandeered the cricket fields of Clare and King's Colleges;

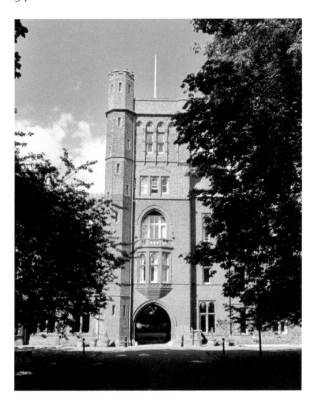

Girton College was a pioneer of women's higher education. Its grand gate tower shows the ambition from the outset to challenge the men. (© Clare Sargent)

70,000 casualties passed through. The site was subsequently developed for the new University Library, which moved out of its ancient cramped quarters in the Schools into a vast new 'powerhouse of learning' designed by George Gilbert Scott and opened by the King in 1934; 1,142,000 books were transferred in eight weeks during the long vacation. Opinion was divided over its 156-foot-tall tower which dominated The Backs. The Second World War saw the town fortunate to escape serious damage from bombing. As student numbers dwindled, their places were filled by military personnel on short courses.

The post-War years saw the pace of change accelerate as government policy promoted social mobility. Two undergraduate colleges were founded in the 1950s. New Hall (now Murray Edwards College) opened in 1954 as a single-sex women's college to help redress the gender balance within the university, moving to its current buildings on Huntingdon Road in 1964. Churchill College was founded in 1958 as a national monument to Winston Churchill and with an emphasis on science and technology. Lucy Cavendish College for mature women admitted its first undergraduates in 1971. In order to keep up with growing numbers, most colleges have continued to build, often with the help of generous donors; for example, St John's and Queens' at opposite ends of The Backs each have a Cripps Building. Another new college, Robinson College, was opened in 1977, endowed by local businessman David Robinson.

At the same time, the numbers pursuing graduate courses increased and continue to rise. Today, graduates make up almost a third of the student body. All colleges admit

Above: The architect of the
Congregationalist seminary of
Westminster College was clearly
briefed to impress.

Right: It is difficult to hide a vast book
store, and the 156-foot tower of the new
University Library was controversial
when first built in 1934.

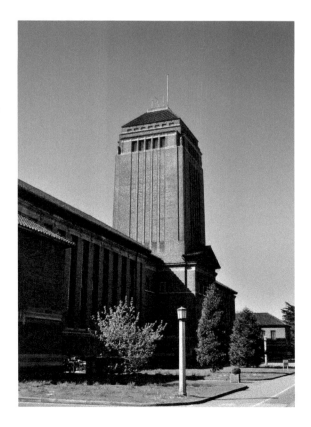

56

graduate students, but the need for targeted support was identified. The 1960s saw
the foundation in quick succession of three graduate colleges: Darwin College (1964),
Wolfson College (1965) and Clare Hall (1966). Hughes Hall and St Edmund's House both
became 'recognised societies' in 1965. The raw concrete façade of the Graduate Centre,
another 1960s structure, overlooks the millpond to provide an extra-collegiate social focus
for graduate students and university teachers alike.

University facilities also chased to keep up with growing numbers. Many new subjects
found a place within the university, while upgraded facilities were urgently required for
established disciplines. One major initiative to address this challenge was the Sidgwick
Site, extending between West Road and Sidgwick Avenue, designed from the 1950s as
a teaching campus for the humanities. This signalled the start of expansion out of the
constricted town centre and into West Cambridge, an expansion which continues to gather
pace – and must continue if the university is to maintain its international reputation.

College life is not all study! Students have time to pursue other interests, some achieving
the highest standards. Schoolboys and students have always played games, but it was not
until the 1830s and 1840s that organised team games began to find a place in public school
education where they were accepted as 'manly and muscular diversions' (to quote Robert
Singleton, Warden of Radley College, 1847–51), healthful and character-building. Colleges
were soon competing between themselves at a growing number of sports, awarding Blues
and Half Blues for representing the university against Oxford. The first varsity cricket
match between Oxford and Cambridge took place in 1827, and the first Boat Race in 1829.

Music has long held its place alongside learning. Each college chapel has its choir, some
of which are of international standing. There are college and university music societies for
every taste; the Cambridge University Musical Society was founded in 1843. Drama has had

The white concrete dome over the dining hall in Murray Edwards College (formerly New Hall)
dates from the 1960s. (© Andrew Sargent)

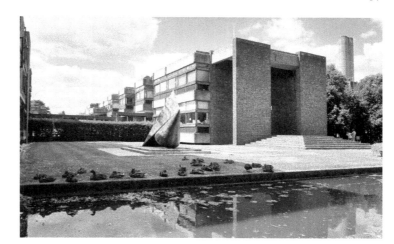

The formal entrance to Churchill College, which specialises in science and gives the traditional college layout a 1960s spin. (© Andrew Sargent)

Robinson, the newest of the undergraduate colleges, is one answer to the pressure of ever-increasing student numbers. The stained-glass window in the chapel was designed by John Piper.

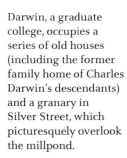

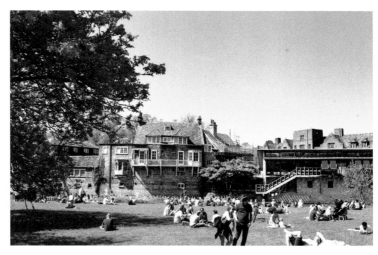

Darwin, a graduate college, occupies a series of old houses (including the former family home of Charles Darwin's descendants) and a granary in Silver Street, which picturesquely overlook the millpond.

a more chequered history, as the vice chancellor had the legal right to regulate theatres to protect student morals. In the sixteenth and seventeenth centuries, several colleges enjoyed a tradition of drama. A theatre operated in Barnwell intermittently from the eighteenth to the twentieth century. The Arts Theatre in Peas Hill, which opened in 1936, is the home of the university's Amateur Dramatic Club, founded in 1855. Equally influential is Footlights, a nursery for student comedy, established in 1881. The tradition of the Cambridge Greek

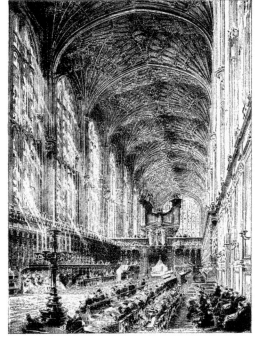

Above: One of several college boathouses beside Midsummer Common. The neighbouring boathouse belongs to the City of Cambridge Rowing Club.

Left: King's College Chapel. (From Clark, J. W., *Cambridge* (Seeley & Co.: London, 1908))

Kettles Yard and St Peter's form an attractive group. Originally four cottages (since extended), from 1957 this was the home of Jim Ede where art could be enjoyed in a domestic setting. He gifted this unique place to the university. (© Andrew Sargent)

play – performed in classical Greek – now staged every three years, originated in 1882. During term time, there must be a concert or play somewhere almost every day.

Among the student body, political debate has generally been of greater interest than political activism. The Apostles, a well-informed though highly exclusive conversation society, was formed around 1830. In the Cold War it achieved notoriety as a recruiting ground for spies; the double-agent Guy Burgess was a member. Less exclusive is the Union Debating Society, which first met in 1815 in a room at the Red Lion Inn. Its present substantial premises behind the Round Church were erected in 1866 to designs by Waterhouse. Many politicians (though surprisingly no British prime minister) took their first public steps there.

Things to See
-The Whipple Museum of the History of Science, access from Free School Lane.
-The Museum of Zoology, with its huge giant finback whale skeleton, on the New Museum Site.
-The Sedgewick Museum of Earth Sciences (geology and fossils), on the Downing Site.
-The Museum of Archaeology & Anthropology, access from Downing Street.
-Kettles Yard Gallery, Castle Street, shows art in a domestic setting.
-The University Library arranges a programme of free exhibitions.

9. A Regular Town

It is easy to take for granted the town which stands in the shadow of the colleges. Apart from its university, post-Reformation Cambridge settled into the mould of a provincial town and local market centre. Physically, it continued to be shaped by its medieval origins, with narrow streets, lanes and passages following its historic plan. Unlike the university, which used architecture as a status symbol, the town was not given a fashionable Georgian makeover, though the key civic buildings were upgraded. In 1747, the administrative centre for the shire moved down from the castle to a newly built shire hall in the marketplace. Then in 1782, a new town hall, designed by James Essex, replaced the old Guildhall. Both the shire and town halls were demolished in 1936 to be replaced by the current Guildhall, which incorporates the Victorian Assembly Room. Elsewhere, several brick townhouses were built by the wealthier citizens, such as Little Trinity in Jesus Lane and Fitzwilliam House in Trumpington Street, both in the 1720s, but these were the exception. Much of the building stock was ageing. A number of town-centre buildings were clad with tiles designed to simulate the fashionable brick, but they were still timber and wattle under the skin.

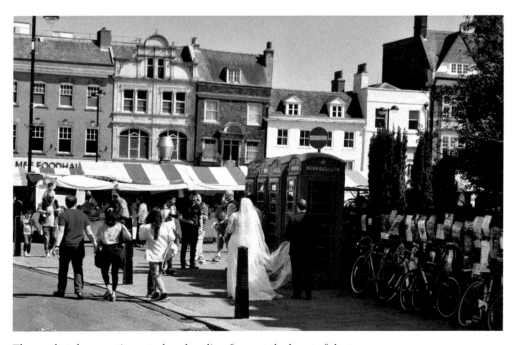

The marketplace continues to be a bustling focus at the heart of the town.

The modern Guildhall presides over the marketplace, as did its medieval predecessors. The fountain replaced Hobson's Conduit.

The Eagle Inn in Bene't Street, with a galleried courtyard, is the last of Cambridge's old coaching inns.

Little Trinity, Jesus Lane, is one of a number of affluent townhouses built in the eighteenth century. Most are now adapted for university or college use. (© Andrew Sargent)

Little improvement had been seen over three centuries. The diarist John Evelyn, in Cambridge in August 1654, was not impressed: 'the whole town is situate in a low dirty unpleasant place, the streets ill paved, the aire thicke and infected by the Fennes, nor are its churches ... any thing considerable in compare with those of Oxford.' Evelyn was, of course, an Oxford graduate and as such found it hard to like much about the rival town. In 1710, the visiting German book collector Zacharias Conrad von Uffenbach likewise found little to commend: 'Were it not for the many fine *collegia* here, it would be one of the sorriest places in the world.' A third poor review was given by Jane Griffin, second wife of the explorer Sir John Franklin, in the summer of 1811: 'The town is extremely ill constructed, the streets being inconveniently narrow & confined & the houses irregular & inelegant'.

The population of Cambridge had grown slowly, from an estimated 6,000 in the 1660s to 10,000 in 1801. However, the physical area of the town had hardly altered since the medieval period as the common fields formed a straightjacket which came right up to the line of the King's Ditch. It had become seriously overcrowded. Tenements were subdivided, back plots were built over, many of the poorer people lived around cramped yards and passages, and houses were in multiple occupancy. These were conditions in which disease quickly spread and fire was a constant threat.

The town had to wait for the Enclosure Acts of 1802 and 1807 before it could break its historic shackles. The newly privatised fields could be sold piecemeal to speculative developers. Expansion was initially slow, in part because enclosure still left the colleges collectively as major landowners, and they were not to be rushed. They placed a premium on the West Field, which they chose to preserve as a greenbelt during the first period of

St Edward's Passage. Medieval Cambridge was a town of lanes and passages.

Trinity Lane. Many of the narrow medieval streets are fossilised in the modern town.

urban growth. Instead, the release of pressure was focussed on the East and Barnwell Fields, resulting in a lopsided development which remains evident in the town plan. Gradually, the movement of population to the new suburbs allowed the crowded centre to be opened up.

New Town, between Trumpington Road and Hills Road, was one of the first suburbs to be developed. The area was divided between eight owners whose different attitudes led to very different results, from high-quality housing in Bateman Street and Norwich Street, commissioned by Trinity Hall and the trustees of Addenbrookes Hospital, to the high-density terraces of Russell Street, which were declared slums and demolished by the local authority in the 1960s. Terraces of often low quality housing went up in the 1820s and 1830s in the area around Fitzroy Street (later known as The Kite), with retail units along the main thoroughfares. Mill Road and Romsey Town developed as a railway quarter in the later part of the century, while the population of Barnwell shot up from 250 in 1807 to 12,000 by 1861 and continued to increase.

The agricultural depression, which began in the 1870s, encouraged colleges to look again at their assets in the old West Field. Their commercial decisions in this area were informed by the desire to preserve the character of their genteel setting. The largest landowner, St John's, took the lead in laying out several new roads off the axis of Grange Road. Building plots of upwards of 1 acre were sold leasehold to retain ongoing control, and the minimum value of each house to be built was specified, ensuring these would be large houses in leafy grounds. Smaller and less expensive, though still exclusive, plots were sold along Madingley Road.

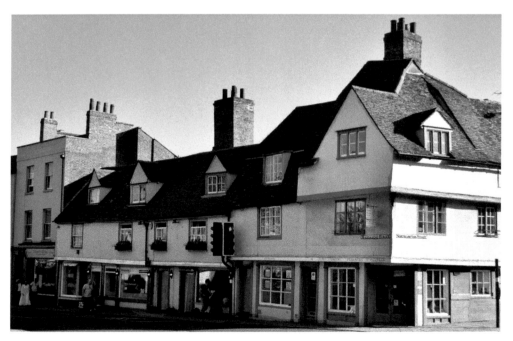

Most early buildings in the town are hidden behind painted plaster. This run of sixteenth-century buildings is at the corner of Magdalene Street and Northampton Street.

Right: The late medieval half-timbered range behind No. 25 Magdalene Street, a well-preserved seventeenth-century timber-framed house.

Below: A mixed housing development of 1815–26 by Charles Humfrey at the west end of Maids Causeway was known as Doll's Close. These substantial houses overlook Midsummer Common. (© Andrew Sargent)

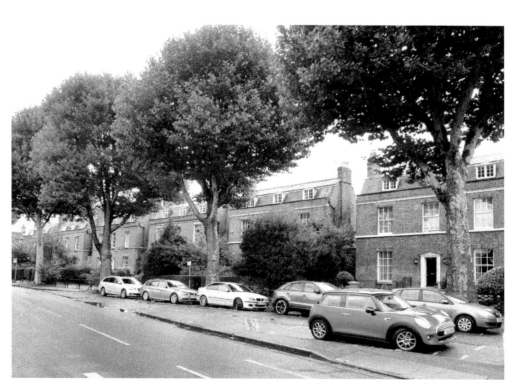

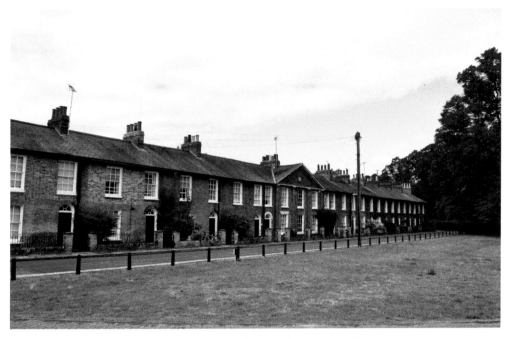

New Square is open towards Christ's Piece. Its three earlier nineteenth-century terraces are given a classical treatment with their central pediments.

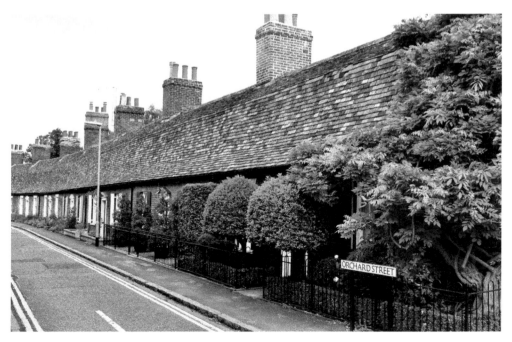

This humble terrace of single-storey cottages with mansard roofs in Orchard Street has a deceptively traditional rural feel.

Religious toleration was slow to find acceptance, both in Cambridge and nationally. The first Catholic church in Cambridge since the Reformation was a simple mission chapel in Union Road, designed by Augustus Pugin and built by its own congregation in the 1840s. In time, a larger church was needed, and Our Lady and the English Martyrs on a prominent site at the corner of Hills Road and Lensfield Road was consecrated on 8 October 1890. Funded entirely by Mrs Lyne-Stephens, widow of a wealthy manufacturer, this cathedral-sized neo-Gothic building by architects Dunn & Hansom reflected a new confidence among Catholics. Remarkably, the statue of Our Lady of Grace, still venerated there, may be the same image which drew a regular flow of pilgrims to the Dominicans' church in the early sixteenth century.

A growing concern for the 'deserving poor' led, from the sixteenth century, to almshouses emerging as a worthy cause for bequests. Despite their good intentions, these charities could provide for a mere handful of the needy. Matthew Stokys, who died 1591, endowed three almshouses in King Street for six poor spinsters, but the site was sold in 1860 to help fund new almshouses in Panton Street. Among other public benefactors, Stephen Perse, who died 1615, founded an almshouse for six single persons who were to come from specific parishes. Perse also established a free grammar school for 100 scholars in Free School Lane, now marked by a blue plaque.

Thomas Hobson established the Spinning House in St Andrew's Street by charitable trust in 1628 as a combined workhouse and house of correction where inmates learned to be responsible citizens by weaving; its role as a prison came to dominate. After the Act of 1723, a workhouse was set up for each parish in the town. It was not until 1838 that this

The Perse Almshouses were moved to Newnham Road in 1886 from their original site in Free School Lane.

system was rationalised and a single Union Workhouse, capable of taking 250 inmates, was erected in Mill Road. This building subsequently served for many years as the maternity hospital.

Another important benefactor was John Addenbrooke, fellow of St Catharine's and a physician, who left a bequest in 1719 to found a hospital specifically for the poor. The hospital, which still bears his name, eventually opened in Trumpington Street in 1766, and for the next two centuries its mission was supported by charitable subscriptions, donations, legacies and benefit concerts. Parts of the original building survive beneath the nineteenth-century additions. The hospital transferred to a new site at the edge of the town in the 1960s, and its old buildings now house the Judge Business School.

Waste disposal and access to clean water, even in this fen-edge location, were perennial challenges for town and gown alike. Most townsfolk relied on shallow wells dug into the gravels in the open areas behind the street frontages, but these shared the space with pits for waste. A public pump in the marketplace also tapped the contaminated ground water. The Franciscans had brought water to their friary from a spring along Madingley Road, charitably maintaining a public fountain outside their gate. The issue only began seriously to be addressed at the start of the seventeenth century. The New River was dug (marked on maps as Hobson's Brook), bringing fresh water from Nine Wells in Great Shelford to the conduit head at the junction of Trumpington and Lensfield Roads, from where it was piped to a public fountain in the marketplace – a remarkable piece of engineering. One of the town's leading benefactors, Thomas Hobson, left an endowment for the maintenance of the system which was named Hobson's Conduit in his memory. In 1856, Hobson's original fountain was moved to the conduit head.

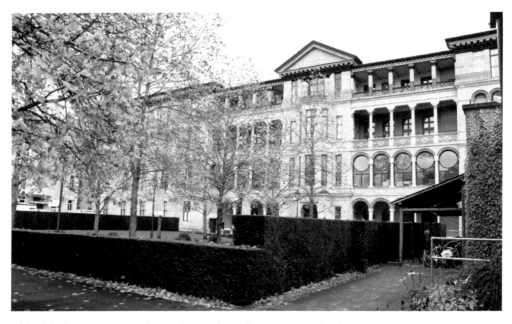

Old Addenbrookes Hospital now houses the Judge Business School.

The fountain known as Hobson's Conduit originally stood in the marketplace and was later moved to the conduit head.

One objective of the Hobson's Conduit scheme was to use excess flow to flush out the King's Ditch, which had long been implicated in the many epidemics that swept the town. The open channels that run down either side of Trumpington Street (originally a single culvert in the middle of the road) diverted water to one end of the King's Ditch. The project attempted too much. The flow was never sufficient to flush the Ditch properly. When an Act of 1788 transferred responsibility for street cleansing, paving, public lighting and drainage from the indigent Corporation to an Improvement Commission, some progress was seen, though the town had to wait until the 1860s before a water company was founded to supply clean water to the growing population. Mains sewerage was further delayed until the end of the century when a sewage pumping station was opened beside the river at Cheddars Lane. Meanwhile, the Cam continued to be used as a drain for all manner of waste.

The former sewage pumping station beside the river at Cheddars Lane is now the Museum of Technology. (© Andrew Sargent)

Cambridge originated as a transport hub; the town's common seal combines a bridge with three ships riding at anchor. In the seventeenth century, town and gown united in their opposition to the draining of the Bedford Level which they believed would end Cambridge's river trade, though this was long past its peak. The feared economic downturn did not materialise, but it prompted lobbying to improve navigation. In 1702, an Act of Parliament established the Conservators of the Cam. They cleared obstructions and built locks, including Jesus Green and Baitsbite locks. Converted warehouses on either side of Magdalene Bridge, and another beside the millpond, testify that the river trade clung on, at least for bulk commodities such as grain and coal, until the arrival of the railway.

Several proposals had foundered before the Eastern Counties Railway began services on 29 July 1845. The enabling Act granted the university intrusive rights, hinting at complex negotiations behind the scenes. Proctors, for example, were empowered to search the station for university members and to prohibit the company from conveying any such member below the degree of MA, while no passengers could be taken up or set down within 3 miles of Cambridge between 10 a.m. and 5 p.m. on Sundays. The location of the station had been an issue, and various, more central, sites had been debated before the present one, a mile outside the town, was approved. The Italianate station building was described as 'exceedingly chaste and appropriate' by the *Illustrated London News*,

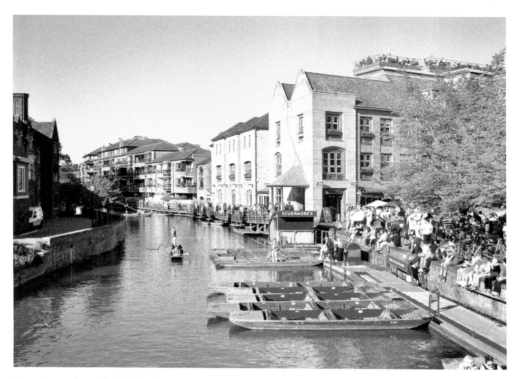

The Quayside and a block of nineteenth-century warehouses testify to the former importance of river transport.

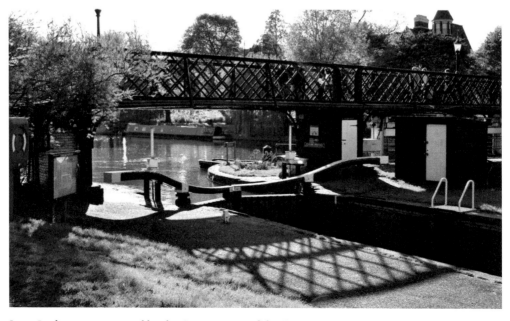

Jesus Lock was constructed by the Conservators of the Cam to improve navigation.

The Italianate façade of the railway station dates from 1845. The arches originally formed an open loggia.

though, unusually, it was designed with (and still has) a single long platform for both up and down traffic.

As the town's wider economic importance declined, the university grew. For centuries it was by default the main employer, either directly or indirectly – from printing and bookbinding, to providing a market for retail goods, to college servants. In the nineteenth century, new opportunities loosened this economic dependency. As the suburbs spread, construction offered new jobs. The railway required its own workforce, while at the same time opening markets for local industries such as milling, cement, and brick and tile manufacture, though few new industries were attracted. Light engineering and electrical manufacturing, often with a research component, developed from the late nineteenth century, while various government-funded research institutes were set up between the wars. However, these were relatively small-scale businesses which did little to change the character of the town.

The later twentieth century saw the emergence of the 'Cambridge Phenomenon' as an economic factor. In the 1970s, Trinity College identified the potential and set up the Science Park in North Cambridge. More recently, St John's Innovation Park was established nearby. Entrepreneurs in the areas of technology and life sciences are attracted to the city by its pool of educated employees, the university's cutting edge research, and the pleasant environment. Many are start-up companies, often spin-offs from university research. Though individually these companies tend to be small, collectively they provide around 30,000 jobs.

This memorial to the men of the county, town and university who served in the First World War (the Second World War was subsequently added) stands at the junction of Hills Road and Station Road.

Things to See
-The Eagle in Benet Street, a rare survival of a coaching inn, loved by generations of students.
-The New River, known as Hobson's Conduit, runs beside Trumpington Road from the Botanic Gardens to Lensfield Road. The public fountain was relocated here from the marketplace.
-The sewage pumping station, now the Museum of Technology, was opened in 1894 beside the river at Cheddars Lane.

10. Green Spaces

Cambridge is a town of green spaces, both public and private, large and intimate. Each college has its hidden lawns and gardens, often still reflecting the hierarchy of college society with separate spaces designated for the master, fellows, and scholars. Perhaps glimpsed through an open gate or hinted at by greenery reaching over a blank wall, they speak of privilege, of a secret life. The manicured, treeless, flowerless, putting-green-flat lawns of King's College are among the more visible triumphs of order over nature. By contrast, Clare College Fellows' Garden, designed in 1947 by E. N. Willmer, is a well-hidden delight and feels intimate after the expanses of neighbouring King's. To mention its riverside location, traditional herbaceous borders, hedged walks and sunken formal pond does not do justice to its profusion of planting or its tranquillity.

The country-in-the-town nature of Cambridge has long shaped perceptions. Selwyn College, founded in 1882, was one of the first university buildings on the west of the river. As one of its early students reminisced, 'Then we were absolutely in the country.' This was still true, at least in the memory, sixty-five years later. The economist John Vaizey, who went up to Queens' College immediately after the War, reflected, 'People from big cities

'Milton's Mulberry Tree' in Christ's College garden is named after the poet John Milton, fellow of the college, who allegedly composed *Lycidas* in its shade.

who go to Cambridge realize what it is like to live in the country. Each Cambridge winter day began with the river smell, mixed with the scent of damp leaves and, as often as not, bonfire smoke.' The author remembers the sweet aroma of stubble-burning filling the air on glorious October days.

In 1978, Hugh Plommer complained that recent development had driven the country out of Cambridge. There has, of course, been change, but most people would regard Plommer's as a hasty judgment. Even today, with development pressures on all sides, the country still penetrates into the historic heart of the town. This contributes to the suspension of disbelief that is Cambridge's unique magic, and the meadow opposite King's College, so often grazed by cattle, maintains the illusion. The Cam draws its ribbon of green through the urban area. Starting upstream, a popular stroll through Grantchester Meadows leads to the Paradise Nature Reserve, Lammas Land and Sheep's Green at Newnham, and on to the delightful surprise which is Coe Fen nestling so close to the bustle of the town, then Queens' Green and The Backs; then, after a brief hiatus, Jesus Green and Midsummer Common; and after another stretch along Riverside, Stourbridge Common and Ditton Meadows follow the river out into rural East Anglia. The many college and public bridges offer wonderful vantage points for drinking in this special place.

One of the glories of Cambridge is The Backs, with its gracious views over the river, meadows and lawns to venerable architectural gems. By the seventeenth century, the riverside colleges were casting covetous eyes over the damp meadows on the further bank, which provided common pasture for the town. Loggan's map, drawn up towards

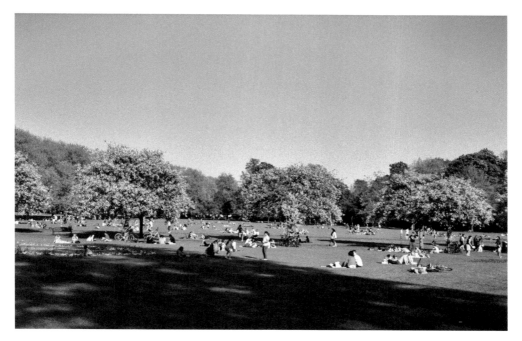

The city centre is ringed with commons. Here townsfolk enjoy a summer's day on Jesus Green.

Above: Enjoying a quiet drink outside the sixteenth-century Fort St George on Midsummer Common.

Left: This old gate through the perimeter wall between Peterhouse and Coe Fen has long been blocked.

Hodson's Folly, Coe Fen. This stone shelter was built in 1887 by John Hodson, butler of Pembroke College, to supervise his daughter, who enjoyed swimming in the Cam. (© Andrew Sargent)

the end of the century, shows how successfully they had achieved their desires. The meadow opposite St John's College, on the map named St John's College Meadow, is laid out as lawns crossed by an avenue of trees and surrounded by a tree-lined walk. Beyond that are a bowling green and further walks, while an area beside the Cam to the north is used for fish ponds to supply the kitchens. Trinity also brought the common meadows into its ambit. In 1613, the College negotiated with the borough, giving Parker's Piece and some other property in exchange for Garret Hostel Green. From there, a private bridge linked Trinity to a meadow of wooded walks and a further area of tended grass extending up to Queens' Road. Loggan reveals the same tale for the full length of The Backs, with each college having appropriated its section of the common meadows. As these meadows were tamed into gardens, the present system of drainage ditches replaced the many old courses of the Cam. On the far side of Queens' Road, the common fields (the West Field) began, where even the colleges could make no inroads.

The Backs is the creation of an enduring vision espoused jointly yet independently by the colleges. Each college liked to imagine itself as a gentlemen's residence set in private grounds. The Gibbs' Building at King's is an example of this conceit, looking across lawns to the river with its meadows beyond. In 1779, Capability Brown prepared a plan to turn The Backs into a shared parkland, with the Cam broadened to create a formal lake with two islands and a carriage drive along Queens' Road. His scheme was not adopted, as individual colleges were unwilling to sacrifice their private grounds to a greater landscape. All he could do was 'improve' some walks at St John's.

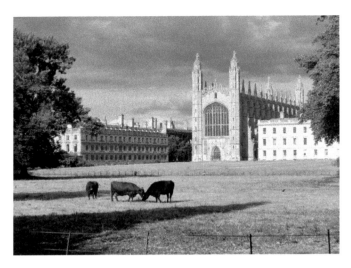

The Backs are one of Cambridge's treasures, and the view of King's College Chapel is perhaps the jewel. (© Andrew Sargent)

The vast acres of West Field, across Queens' Road, were enclosed in 1802 by an Act of Parliament. The university was concerned at the implications of enclosure. The town was overcrowded and this was prime development land. The colleges, however, valued their genteel landscape settings and the opportunity for quiet promenades, so a syndicate was formed to safeguard their interests. In the event, the university and colleges were allocated 60 per cent of the enclosed land while other institutions were granted a further 25 per cent, placing them in a strong position to veto unwelcome change. When further enclosure opened up development opportunities on the other side of the town, the old West Field was freed to become a patchwork of tenant farms, gardens and pleasure grounds, and later, sports fields. It was not until the 1870s that the controlled development was initiated, which created the leafy, exclusive suburb along Grange Road.

Public green spaces also bring nature into the built-up area. The University Botanic Garden, Parker's Piece and Christ's Piece are valued lungs. Initially common pasture on the edge of the town, Parker's Piece was levelled for use by three college cricket clubs. Fenner's, the university cricket ground, still neighbours Parker's Piece. Today, each college maintains its sports ground, collectively constituting a considerable acreage of mown grass.

The University Botanic Garden in Trumpington Road opened in its present location in 1846. The original botanic garden was founded as a physic garden in 1762 on a cramped site near the marketplace, with the simpler remit of growing plants used in the teaching of medicine. By the nineteenth century, botany had progressed as a science. The spacious 40 acres of its new location allowed the Garden to stretch and develop, with glasshouses, a rock garden and a lake to create tailored conditions for over 8,000 plant species. While its primary purposes are education and research, it provides a beautiful oasis of peace at all seasons and an inspiration for gardeners. John Henslow, Professor of Botany, who was the motivating force behind its early development, was also Charles Darwin's teacher and wrote a reference for him to join the *Beagle* voyage.

Added together, college sports fields represent a huge acreage of mown grass.

Hobbs' Pavilion, Parker's Piece, is named after Sir Jack Hobbs, the first professional cricketer to be knighted. Born in Barnwell, he learned the game on Parker's Piece. (© Andrew Sargent)

These green spaces are not a fortunate accident. The colleges have long fought to preserve their own leafy settings, though the wider battle was taken up by others. Local people from both town and university found themselves increasingly concerned about the impact of government building programmes. Out of this arose, in 1928, the Cambridge Preservation Society – now Cambridge Past, Present & Future – with the aim of campaigning to protect the character, setting and amenity of Cambridge as a historic city of global importance while still recognising the need for progress. Today, the charity manages, among other sites, the Leper Chapel and Wandlebury Country Park. Involvement with the planning process is not glamorous, but Cambridge PPF's quiet successes continue to contribute to the preservation of this special place.

The University Botanic Garden moved to its present site on Trumpington Road in 1846.

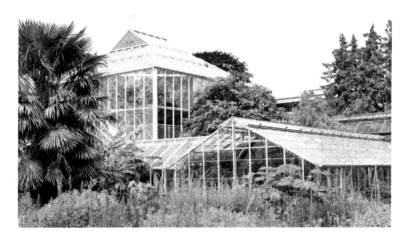

The Botanic Garden is 40 acres of horticultural tranquility. Different conditions are provided to suit a variety of plants, including a range of glasshouses.
(© Clare Sargent)

Things to See
-The Backs, from the footpath that runs alongside Queens' Road.
-Clare Fellows' Garden.
-The University Botanic Garden, Trumpington Road.
-Coe Fen, follow the river upstream from the millpond.
See also Walk 4.

11. Suburban Villages

From its nucleus within the King's Ditch, Cambridge has become a city of 125,000. Prior to the enclosure of the common fields in 1802–07, it had no real suburbs. Ordnance Survey maps of the 1830s–50s still showed a compact town set in a wide landscape of farms and small rural communities. Since then, the expanding population has filled in the green spaces between the villages before absorbing them. In recognition of this changing reality, they were brought within the administrative boundary in 1912 and 1935.

Medieval Chesterton was a royal manor a mile outside Cambridge, with Cambridge castle located at the very edge of the estate rather than being administratively part of the town. Excavation has confirmed the settlement's Saxon origins, perhaps as early as the eighth century, when its focus may have been a crossing of the Cam near the site of the largely fourteenth-century St Andrew's Church. The church was granted by Henry III to the papal legate, Cardinal Gualo, who in turn gave it to his foundation of canons regular at Vercelli, in Italy. A survivor from this period is Chesterton Tower, a two-storey stone house built for the abbot of Vercelli's representative. Around 1440, both church and house were given to King's Hall and thence to Trinity College.

Mill Road is a bustling suburban commercial street.

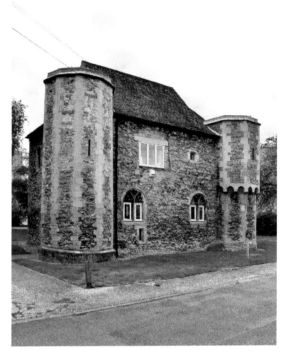

Left: Chesterton Tower is a rare survival, a mid-fourteenth-century house built for the Abbot of Vercelli's representative.

Below: This range of four sixteenth-century houses in Water Street, Chesterton, is now the Green Dragon inn. (© Andrew Sargent)

The small community of Augustinian canons was relocated to a greenfield site in Barnwell in 1112. A settlement grew up outside their gate, and in 1279 the Hundred Rolls recorded ninety-five tenements. The priory ruins survived into the early nineteenth century when they were systematically dismantled. Little now remains. The thirteenth-century Church of St Andrew the Less stood outside the priory enclosure to serve the settlement, later becoming the parish church. The enigmatic stub of a building on the corner of Beche Road and Priory Road, known as the Cellarer's Chequer, also dates from the thirteenth century, though its function within the priory is lost. Abbey House post-dates the priory. Just a mile from the crowded town centre, the population of Barnwell grew quickly once the common fields had been enclosed, from 252 in 1801 to 11,776 in 1851. Streets of terraced housing designed for different classes were thrown up, and new churches catered for the residents; Christ Church on Newmarket Road is a reimagining of King's College Chapel in red brick, while the octagonal shape of St Matthew's, Geldart Street, vaguely recalls the octagon of Ely Cathedral.

The small hamlet of Newnham has long been linked with the town. Just a short walk across the Small Bridges, it could be cut off by winter flooding – as the Carmelites discovered. Its location on the favoured west bank of the Cam ensured that it avoided the levels of suburban development, which have buried the old cores of other close-in villages, and it remains spacious and leafy. For a long time it was part of Grantchester parish, and its church of St Mark was a chapel of ease. The original chapel of 1871 was an iron-clad mission hall.

St Andrew the Less, Newmarket Road, was the gate chapel to Barnwell Priory, at the Reformation becoming the parish church.

The Victorian Christ Church was built to serve the growing suburb of Barnwell. It drew inspiration from King's College Chapel. (© Andrew Sargent)

Picturesque Grantchester has also survived the development of Cambridge, and it remains a favourite destination for town dwellers strolling out through the riverside meadows on a sunny Sunday afternoon, or punting between the overhanging willows. The footpath is surfaced, the result of a bequest by two college fellows. The poet Rupert Brooke lodged at the Old Vicarage and loved the village, which he immortalised in his poem, 'The Old Vicarage, Grantchester'. Brooke and his Bloomsbury friends swam in the mill pool, as Byron had done before them. Imagine them enjoying a relaxed afternoon tea in the shade of the apple trees at the Orchard Tea Room. If the weather is less tempting, try the thatched pub. Brooke's name is now carved on the war memorial outside the parish church with its fragments of Norman carving.

Trumpington is part suburb, part village, bisected by the busy main road. A few seventeenth-century brick houses survive beside the A1309 alongside their recent neighbours, together with a few thatched roofs; the Green Man inn incorporates a medieval hall-house. A short walk down Church Lane gives a hint of the old village. The Church of St Mary and St Michael is famous for the brass to Sir Roger de Trumpington who died in 1289, one of the earliest monumental brasses in the country. In the mid-seventh century this was clearly a place of some significance, testified by the gold and garnet brooch which accompanied the burial of a young girl.

Above: The tower clock of St Andrew and St Mary, Grantchester, was immortalised by the poet Rupert Brooke.

Right: The brass to Sir Roger de Trumpington (d. 1289) in Trumpington church is one of the oldest in the country. (From Lysons, D. & S., *Magna Britannia: Cambridgeshire* (London: 1808))

The Green Man, Trumpington, is built around a fifteenth-century timber-framed hall house.
(© Andrew Sargent)

Recent excavation in Cherry Hinton has located extensive Roman and Saxon settlements around Church End, as well as a 6-hectare enclosure which may be the site of the manor mentioned in the Domesday Book. In origin this appears to have been a village of two halves separated by fields, Church End and Mill End, and was divided between two manors, Netherhall and Uphall. Today, the oldest building is St Andrew's Church with its twelfth-century tower arch and thirteenth-century chancel. Elsewhere, a few earlier houses survive among the later development, including the Red Lion inn with a timber-framed sixteenth-century core. Unusually, the High Street passes over a functioning level crossing.

The secluded village of Fen Ditton lies just outside the city boundary and as yet has escaped serious development, though that part of the parish within the city is built up. The charming historic core creeps parallel to the river before reaching a dead end. Its single street is lined with old village cottages interspersed with recent homes. Despite a Victorian restoration, the Church of St Mary the Virgin preserves many early details. The seventeenth-century Ditton Hall and three historic inns complete the atmosphere of a rural retreat. It is a pleasant place from which to watch the Bumps.

Splendid lancet windows in the chancel of St Andrew, Cherry Hinton. (© Andrew Sargent)

Things to See

-Chesterton Tower, tucked away off Chapel Street, is a remarkable survival of a complete fourteenth-century dwelling. (Private)

-A pretty range of sixteenth-century buildings in Water Street, Chesterton, includes the Green Dragon inn.

-St Andrew the Less in Newmarket Road and the Cellarer's Chequer (view externally) in Beche Road are fragments of Barnwell Priory.

-The clock on the tower of Grantchester Church used to be kept at 10 to 3 in homage to Rupert Brooke's poem. The poet's name is on the war memorial.

-The Church of St Mary & St Michael, Trumpington, boasts the memorial brass to Sir Roger de Trumpington (died 1289), one of the earliest in the country.

12. Walks for the Curious

Most visitors to Cambridge will stroll on The Backs and visit a selection of colleges and perhaps a museum. Guided walks and punt tours are readily available. This chapter will help the reader explore a few less visited but equally interesting locations.

Walk 1: The Roman Town and Castle
This walk explores the site of the walled Roman settlement on the hill overlooking the river crossing.

The peaceful St Peter, Castle Street, is now cared for by the Churches Conservation Trust.

1) Start at the Quayside. Cross Magdalene Bridge. On your right is Magdalene College, including the buildings of the Benedictine *studium*. Many of the buildings on your left are sixteenth- and seventeenth-century.

2) Continue up Castle Street. This is approximately the line of the Roman Via Devana. The river gate, not yet located, may lie beneath St Giles's Churchyard. Pause to see the doorway and chancel arch from Picot's Augustinian priory, which are built into the later church.

3) On the left, the peaceful St Peter's rests in its leafy churchyard. Its east end was demolished in the 1780s, but what remains is a delight.

4) As you reach the top of the slope, the grassy motte of the Norman castle is on your right. Enjoy the view from the summit. The rest of the castle lay beneath the Shire Hall, filling the corner of Roman town.

5) The Via Devana continues northwards towards Huntingdon. Turn left into Mount Pleasant, which roughly follows the line of the Roman defences. Where Albion Row meets Mount Pleasant, the site of the west gate has been proved by excavation.

6) Continue across Albion Row into Haymarket Road and the cobbled Honey Hill. The wall ran along the line of the street with the ditch to your right.

7) Turn left into Northampton Street. The defences crossed the small green on your left around which Kettles Yard and some recent houses are grouped.

8) At the crossroads turn right into Magdalene Street. For light relief, glance up at the carved brackets on the seventeenth-century No. 25. Return to the Quayside.

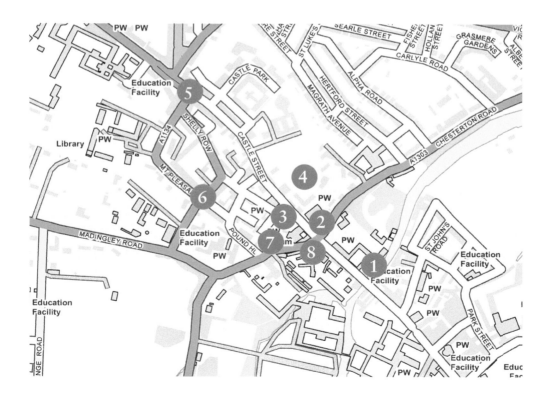

Walk 2: The King's Ditch

This walk follows the line of the King's Ditch which defined the medieval and later town, though nothing is visible above ground. Imagine a continuous ditch, bank and timber palisade broken by three gates.

1) Starting at the millpond, walk up Mill Lane. The Ditch ran beneath the buildings to your left; you are outside the medieval town.

2) Cross Trumpington Street – the site of the Trumpington Gate – and continue up Pembroke Street. The Ditch was still on your left.

3) The Ditch cut across what is now the New Museum Site, so continue along Downing Street and follow the walkway beside Corn Exchange Street into the Grand Parade shopping precinct. Once inside, bear left then right. A section of the Ditch was excavated beneath Grand Parade.

4) Leaving the Grand Arcade, the Ditch passed immediately to the west of St Andrew the Great. Follow the pedestrian way and cross St Andrew's Street. This was the site of the Barnwell Gate.

5) Continue down Hobson Street. Where the road bends into King Street, the Ditch continued across the grounds of Sidney Sussex College. Turn left down Malcolm Street and left again into Jesus Lane.

6) Rejoin its course as you cross into Park Street and New Park Street, finally following the pedestrian alley through to the riverside. The Ditch opened into the Cam opposite the Pepys Library.

7) Return along the riverside walkway to Magdalene Bridge.

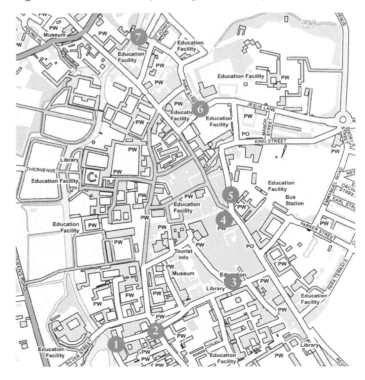

Walk 3: A Church Crawl

Cambridge is an ideal town for a church crawl. In addition to parish churches and the churches of other denominations, each college has its own chapel. Every story is unique.

1) Start at the tranquil St Peter's in Castle Street. This is a stub; the east end was demolished in the eighteenth century, leaving a fourteenth-century tower, thirteenth-century south door and blocked twelfth-century north door.

2) At the foot of Castle Street, Victorian St Giles's preserves fragments of Picot's twelfth-century priory church.

3) Continue over the bridge and along Bridge Street. St Clement's may just possibly be a Danish dedication, though much of what you see is sixteenth-century and the delicate tower eighteenth-century.

4) Continue along Bridge Street. The twelfth-century Round Church was founded by a short-lived Fraternity inspired by the Church of the Holy Sepulchre in Jerusalem.

5) Leaving the church, cross Bridge Street into St John's Street. On your left you pass a small fenced area, formerly the site of All Saints, the tower of which spanned the pavement.

St Mary the Less. Memorial to Godfrey Washington (d. 1729), great-uncle of George Washington, first president of the USA. The family arms include the stars, stripes and eagle familiar elsewhere! (© Andrew Sargent)

St Andrew the Great. Memorial to Captain James Cook the explorer, who died on Hawaii, and family. Only his widow and two sons are buried in this church. (© Andrew Sargent)

6) Just past Rose Crescent is St Michael's, part of which is now a café. It was rebuilt in the 1320s by Hervey de Stanton, founder of Michaelhouse.

7) Next, St Mary the Great, the university church. Rebuilt from the ground in the 1480s, like St Michael's it represents a single phase of construction. Enjoy the view from the tower.

8) Proceed along King's Parade leaving King's College Chapel on your right and turn down St Edward's Passage. St Edward King and Martyr presents its thirteenth-century west tower to the visitor.

9) Return to King's Parade and then left into Benet Street to see the oldest building in Cambridge. St Bene't's preserves its Saxon tower and less visible Saxon stonework in the chancel. Externally, note the long-and-short work on the corners of the tower and the window openings; internally, note the tower arch with lions on the corbels.

10) Return to King's Parade, turn left and walk on to St Botolph's, a typical dedication for a church at a town gate.

11) Continue into Trumpington Street. On either side of Little St Mary's Lane are Emmanuel URC Church of 1875 and St Mary the Less. Originally St Peter without Trumpington Gate, Little St Mary served as the chapel for Peterhouse until the 1660s. It may even be Saxon in origin, but was rebuilt by the college in the 1340s. Inside, note the memorial to George Washington's great uncle.

12) Continue along Trumpington Street and left into Lensfield Road. The Catholic Church of Our Lady and the English Martyrs dominates the junction with Hills Road.

13) Next follow St Andrew's Street, a long and surprisingly soulless road. Opposite Christ's College is St Andrew the Great. Originally immediately outside the Barnwell Gate, this medieval church was completely rebuilt in 1842–43 by Ambrose Poynter. It contains a memorial to Captain James Cook, the navigator, his widow and children.

14) Continue along St Andrew's Street and turn into Market Street. Here is Holy Trinity, large, and of many periods from the twelfth century onwards.

15) Return to St Andrew's Street and Sidney Street, turning right into Jesus Lane. The tall spire indicates All Saints, replacing the church of the same name which stood in St John's Street. Built in 1864 by G. F. Bodley, its tall interior was decorated by William Morris and his followers.

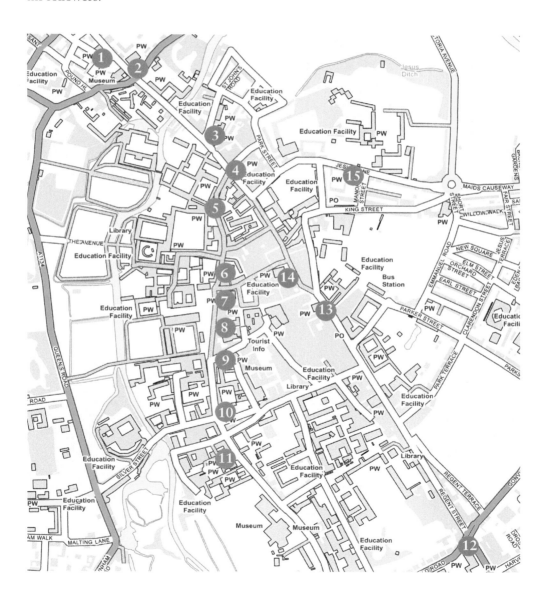

Walk 4: Following the River Downstream

This pleasant summer walk of about 2 miles takes in three riverside commons as the Cam leads you from the centre to the edge of the town. It is a linear walk, so you will have to retrace your steps.

1) Starting on Magdalene Bridge, walk down to the Quayside and along the boardwalk which overhangs the river. Magdalene College is on the opposite bank.

2) Continue across Jesus Green, following the tarmac path beside the river. You will pass Jesus Green lock and footbridge, then the lido on your right.

3) Follow the path under the Victoria Avenue road bridge onto Midsummer Common and continue beside the river. Pass the sixteenth-century Fort St George inn, then a run of boathouses on the opposite bank.

4) The path goes under Elizabeth Way road bridge into Riverside (a road – watch for traffic). You are now in Barnwell. Continuing beside the river, pass the Cambridge Museum of Technology (former sewage pumping station) and the new Riverside Bridge.

5) The road ends at Stourbridge Common, site of the great medieval fair. Follow the tarmac path beside the river.

6) Cross into Chesterton via Green Dragon Bridge. You are facing the Green Dragon inn, a picturesque range of four sixteenth-century cottages.

7) Turn right along Water Street, bearing right at the bollards at the end of the road. Just past the row of houses, join the towpath. This section of the river is used for the Bumps races. As the towpath soon enters open country and continues for many miles, you may wish to turn back.

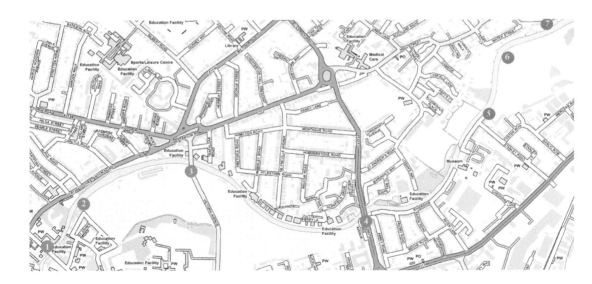

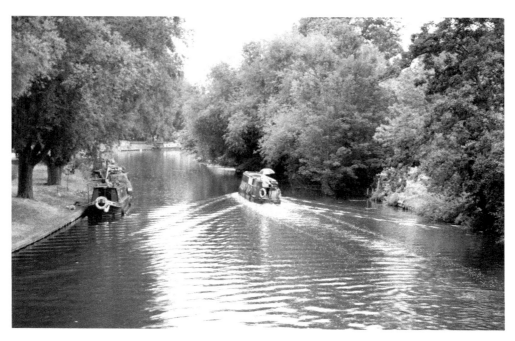

Barges moored alongside Stourbridge Common. (© Andrew Sargent)

13. Further Reading

The following titles will allow the reader to explore further.

Alexander, J. & J. Pullinger, 'Roman Cambridge: Excavations on Castle Hill 1956–1988' in *Proceedings of the Cambridge Antiquarian Society,* Vol. 88 (a dedicated issue, 1999).

Bradley, S. & N. Pevsner, *The Buildings of England: Cambridgeshire* (London: Penguin Books, 2014).

Brooke, C. N. L. (ed.), *History of the University of Cambridge,* 4 vols (Cambridge University Press, 1989–2004).

Gray, R., *Cambridge Gardens* (Cambridge: The Pevensey Press, 1984).

Leedham-Green, E., *A Concise History of the University of Cambridge* (Cambridge University Press, 1996).

McWilliams-Tullberg, R., *Women at Cambridge: A Men's University – Though of a Mixed Type* (London: Victor Golancz, 1975).

Oxford Dictionary of National Biography (available online at http://www.oxforddnb.com/public/index-content.html).

Ray, N., *Cambridge Architecture: A Concise Guide* (Cambridge University Press, 1994).

Roach, J. P. C. (ed.), *A History of the County of Cambridge and the Isle of Ely: Volume 3, The City and University of Cambridge* (London: Victoria County History, 1959).

Royal Commission on the Historical Monuments of England, *An Inventory of the Historical Monuments in the City of Cambridge,* 2 vols. (London: HMSO, 1959).

Taylor, A., *Cambridge: The Hidden History* (Stroud: Tempus, 1999).

Willis, R. & J. W. Clark, *The Architectural History of the University of Cambridge,* 3 vols (Cambridge University Press, 1886).

Many useful articles can be found in the *Proceedings of the Cambridge Antiquarian Society.* Histories of individual colleges are in print and many colleges publish a guidebook.